Never speak to your family again or never get married?

Date a movie star or rock star? *Rock Star*

Give up your favorite food for a year or give up candy forever? *Favorite Food*

Pet unicorn or pet dragon? *Married*

Fly a kite in a rainstorm or walk bare feet on hot coals? *Dragon*

Hitchhike with strangers cross country or get cross country by train hopping? *Hot Coals*

Bit by a vampire or a dog with rabies? *Vampire* *Train Hopping*

3000 Would you Rather Questions

Follow us on social media!

Tag us and use #piccadillyinc in your posts
for a chance to win monthly prizes!

© 2019 Piccadilly (USA) Inc.

This edition published by Piccadilly (USA) Inc.

Piccadilly (USA) Inc.
12702 Via Cortina, Suite 203
Del Mar, CA 92014
USA

10 9 8 7 6 5 4 3 2 1

Printed in China

ISBN-13: 978-1-62009-162-3

1 **WYR** give up your favorite food for a year or give up candy forever?

2 **WYR** live in a windmill or lighthouse?

3 **WYR** be an angel on your friend's shoulder or a devil on your enemy's shoulder?

An angel on my friends Shoulder

4 **WYR** eat an entire jar of olives or sauerkraut in 15 minutes?

An Entire jar of Olives

5 **WYR** spend your life looking for love or have the greatest love one could know, complete with love story but only for one year?

Have the greatest love one could Know, but only for one year.

6 **WYR** write and have a best-selling book published or star in a hit blockbuster movie?

Write and have a best-selling book Published

7 **WYR** go on a trip around the world with your best friend or a week-long vacation at a resort in Hawaii with your significant other?

a resort in Hawaii week-long vacation at with my significant other.

8 **WYR** serve one year in active combat in the United States Army or volunteer for a year doing missionary work in impoverished countries?

9 **WYR** have a chauffeured limo the rest of your life (meaning you can never drive again) or drive the car of your dreams the rest of your life but only drive that car?

10 **WYR** get lost in the woods at night, having to find your way out or sleep in a cemetery with your best friend?

11 **WYR** have Stan Lee or Kevin Smith create your own comic book character?

12 **WYR** get a tattoo of a cartoon character or a tattoo of the face of a celebrity you like?

13 **WYR** live in paradise for free but you can only take four people or live in the city where you were born but can never leave?

14 **WYR** take cooking lessons from a celebrity chef or piano lessons from an acclaimed musician?

15 **WYR** eat ice cream every day for a year or go without ice cream for two years?

16 **WYR** have lunch with an influential billionaire or with your celebrity crush?

17 **WYR** have a jacuzzi in your bedroom or a secret room in your house?

a Secret room in my house

18 **WYR** go on a shopping spree with no budget but be limited to one store or a shopping spree at many stores but can only spend 10,000?

a shopping Spree at many Stores but can only spend 10,000

19 **WYR** own your own sports team on a losing streak or own a successful chain of restaurants?

Own a Successful chain of restaurants

20 **WYR** ride the scariest roller coaster in the world or bungee jump off the tallest bridge in the world? *Ride the scariest roller coaster*

21 **WYR** face your worst fear head on or confess your greatest sins online and it go viral?

face my worst fear head on

22 **WYR** confess to a crime you didn't commit or confess to your spouse about an affair you've had?

23 **WYR** drink water from a glacier or a running spring?

Glacier

24 **WYR** give up watching movies the rest of your life or never ever read another book?

25 **WYR** donate an organ to a friend in need or sell one to a stranger for tons of money?

Donate an organ to a friend in need.

26 **WYR** be in shape and have a great body but ugly face or have a gorgeous face but be overweight? *Gorgeous face and overweight.*

27 **WYR** have a super power that you could only use for good or have unlimited time travel ability?

28 **WYR** be a teacher in a public school that's in a bad neighborhood and make a big difference in kids' lives but earn a modest salary or teach brats in a private school for a large salary?

A teacher in a Public school in a bad neighborhood and make a big difference in Kids' lives but earn a modest salary

29 **WYR** live in the fantasy world of Lord of the Rings as a hobbit or live in an unknown world of Star Wars as a Jedi who must fight?

Lord of the Rings

30 **WYR** have a pet unicorn or have a pet dragon?

Pet dragon

31 **WYR** fight the superhero Captain America or fight the villain The Joker?

Joker

32 **WYR** work as an Oompa Loompa in _Willy Wonka's Chocolate Factory_ or be a Lollipop kid in _Wizard of Oz?_

Oompa Loompa

33 **WYR** go on tour as a roadie for your favorite band or be a key part of an entourage for a band whose music you don't like?

34 **WYR** pillage the high seas with Blackbeard the Pirate or try and discover new land with Christopher Columbus?

discover a new land with Christopher columbus.

35 **WYR** have a lifetime of guaranteed happiness and joy or 1 million dollars instantly but no promise of happiness?

lifetime of happiness and joy.

36 **WYR** work with dead people in a mortuary or work in the busiest ER trauma unit in the world?

37 **WYR** learn how to fly a helicopter or learn how to fly a plane?

38 **WYR** have the wedding and honeymoon of your dreams and only be married 5 years or courthouse wedding with no honeymoon and be married a lifetime?

Courthouse wedding.

39 **WYR** be abducted by aliens for a year and be returned or take part in a 3-week clinical trial, where you'll be paid but have a lifetime of side effects?

40 **WYR** play strip poker with strangers or truth or dare with your enemies?

41 **WYR** adopt a baby from a poverty-stricken country who could die or adopt your friends' baby who just doesn't want a child?

adopt a baby from a poverty-stricken country.

42 **WYR** be a famous soap opera star or be given the chance to direct a major motion picture?

43 **WYR** enter an archery competition or be challenged to a duel?

44 **WYR** earn a Pulitzer or be given a medal of honor for a heroic act?

45 **WYR** never speak to your family again or never get married?

46 WYR attend a dayglow or foam party?

47 WYR put a spider or ice cubes down your boo's shirt?

ice cubes

48 WYR make a mean person cry or a sweet person laugh?

sweet person laugh

49 WYR have a pinball machine or Pac Man arcade machine for your home?

Pac Man arcade machine

50 WYR hang out with Cookie Monster or Captain Crunch?

cookie monster

51 WYR someone hack your bank account or your Facebook account?

Facebook account

52 WYR wet the bed or your significant other wet the bed so you can laugh?

me wet the bed

53 WYR divulge family secrets or details of your love life in your tell-all book?

54 WYR have annoying friends who are loyal or cool friends that are shady?

annoying friends that are loyal

55 WYR get lost in New York or Los Angeles?

LA

56 WYR talk like SpongeBob or Woody?

Woody

57 WYR have computer commands for your life or an eraser for your life?

58 WYR discover a new island or new civilization?

New civilization

59 WYR have more muscular arms or legs?

arms

60 WYR be rebuilt as part machine or part animal if you had a devastating accident?

Part machine

61 WYR have a sports car with or without a convertible top?

with

62 WYR go water skiing or snow skiing?

water skiing

63 WYR have uncontrollable blinking or have your nose flare nonstop?

uncontrollable blinking

64 WYR your sneeze sound like a siren or a fog horn?

siren

65 WYR workout with kettle bells or free weights?

66 WYR your tongue turn purple or your lips turn blue?

tongue turn purple

67 WYR have a pet chinchilla or sugar glider?

chinchilla

68 WYR lick a salt lick after a cow or suck a honeysuckle after a hummingbird?

suck a honeysuckle

69 WYR swing on a porch swing or tire swing?

porch swing

70 WYR blow bubbles that play music when they pop or turn into pennies when they pop?

play music

71 WYR obsess about your image or let it go?

let it go

72 WYR take classes you find interesting or ones you think you'll need?

interesting

73 WYR be a deal maker or a heart breaker?

deal maker

74 WYR create a list of life hacks or list of goals?

life hacks

75 WYR achieve a deeper understanding or a higher learning?

76 **WYR** risk everything for love or risk everything for a chance at success?

& love

77 **WYR** appear as a guest on your favorite TV show or have lifetime backstage passes for any concert you attend?

78 **WYR** host your own talk show on TV but interview regular people or your own podcast with the chance to interview celebrities and athletes? *Podcast*

79 **WYR** lead a comfortable life, complete with stability but not exciting or live a life full of risk and thrills but not always stable? *life full of risk*

80 **WYR** abolish war or find a cure for every type of cancer?

81 **WYR** be reincarnated as an eagle or a lion?

eagle

82 **WYR** have a robot servant or a real life personal assistant?

real person

83 **WYR** be trapped on a desert island with your significant other or a survivalist?

Significant ~~survivor~~
Other

84 **WYR** donate only your heart to a young baby in need when you die or all of your other organs (except your heart) to various adults in need?

young baby

85 **WYR** be a judge in a criminal court and have to make tough decisions about criminals' future or a family court judge and impact families?

family court judge

86 **WYR** spend the rest of your life rescuing abused and abandoned animals or counsel runaway teenagers?

87 **WYR** know the exact time and place you'll die or have the option to choose how you will die?

88 **WYR** never have another headache the rest of your life or get paid $100.00 for each bad headache you have the rest of your life?

89 **WYR** have all your teeth fall out at once or all your hair?

90 **WYR** attend the Olympics in its entirety or go to a Super Bowl game?

91 **WYR** be an infamous black-hat hacker or the world's best pick-pocket?

92 **WYR** go on an archaeological dig and find a fossil or go gold mining and find some gold?

93 **WYR** enter a singing competition for one million dollars or a dance competition for your own show in Vegas?

94 **WYR** try and train an elephant or a tiger?

95 **WYR** sunbathe nude on a public beach or have a nude scene in a Broadway play?

96 **WYR** date a movie star or rock star?

97 **WYR** hitchhike with strangers across country or get cross country by train hopping?

98 **WYR** have passes to the ballet for a year or sporting event tickets for the team of your choosing but for only one season.

99 **WYR** die 10 years before your time but be allowed to haunt those that hurt you and your family or die on time and be an angel that can help everyone but your own family?

100 **WYR** own a stolen Picasso that you could never show off or own the Hope Diamond, but it always had to be kept in a museum?

101 **WYR** be a lawyer that only defends guilty clients, but you make lots of money or defend innocent clients who were wrongly convicted and make modest income?

102 **WYR** be single for a year (this includes no dating) or go on bad dates for a year straight?

103 **WYR** be put in jail 10 years for a crime you didn't commit but get exonerated and win a big lawsuit or get away with a bad crime and live a haunted life?

104 **WYR** spend your summer as a lifeguard on a popular, busy beach and party all summer or conduct important marine biology research but live on a boat all summer?

105 **WYR** fight off an anaconda or a crocodile?

106 **WYR** get rid of pesticides or growth hormones in food?

107 **WYR** jump like a kangaroo or the have the speed of a Mako shark in water?

108 **WYR** eat sundaes with or without a cherry?

109 **WYR** eat more vegetables or fruit?

110 **WYR** go back five years or skip ahead five years in your life?

111 **WYR** hang glide or windsurf?

112 **WYR** kiss a gecko or June bug?

113 **WYR** grub Big Macs or Quarter Pounders?

114 **WYR** watch the Summer Olympics or Winter Olympics?

115 **WYR** have a duck that oinks or a pig that quacks?

116 **WYR** have a squeeze of lime or lemon?

117 **WYR** text only in GIFs or emojis?

118 **WYR** Google yourself or your ex?

119 **WYR** have your mom or your dad pick out your clothes?

120 **WYR** drown your popcorn in melted butter or cover your ice cream with sprinkles?

121 **WYR** eat broccoli or cauliflower?

122 **WYR** have butterscotch or toffee?

123 **WYR** tie-dye your hair or only wear tie-dye outfits?

124 **WYR** have pizza rolls or pizza bagels?

125 **WYR** control your joystick to your video game by using your foot or mouth?

126 **WYR** have more followers on Twitter or Instagram?

127 **WYR** shop exclusively at Old Navy or H&M?

128 **WYR** wear one of your dad's shirts or your mom's sweaters?

129 **WYR** have cornbread or garlic bread?

130 **WYR** have fish sticks or fresh fish?

131 **WYR** cannonball or dive into a pool?

132 **WYR** view the world as a stage or a playground?

133 **WYR** have creamy or chunky peanut butter?

134 **WYR** have grape jelly or strawberry jam?

135 **WYR** get a shoulder or foot massage?

136 WYR learn about secrets that inspired conspiracy theories or become part of a secret society?

137 WYR go to space on the next mission or compete on your favorite game show for a chance to win millions?

138 WYR be a firefighter for a day or do a ride along with cops from the most dangerous city in America?

139 WYR get a brand-new car for yourself or have the option to give 3 people of your choosing (except significant other) new cars?

140 WYR meet Abraham Lincoln or Ghandi?

141 WYR get rid of all the hatred and racism on Earth or remove every single disease (not illnesses, only diseases) from the planet?

142 WYR bribe someone or blackmail someone to get what you want?

143 WYR go on a treasure hunt around the globe or trace your family history?

144 WYR attend a séance or a Native American sweat ceremony?

145 WYR live off grid the rest of your life or live in a mansion that was haunted with dangerous spirits?

146 WYR eliminate the mob or eliminate the cartel?

147 WYR do over the last 5 years of your life knowing what you know or have 5 years added to your life?

148 WYR improve the conditions of schools and pay teachers more money or employ more people by building more prisons to house more criminals?

149 WYR try and survive a zombie apocalypse or a real-life Purge?

150 WYR try and attempt Mt. Everest or compete in the Alaskan Iditarod Race?

151 **WYR** be a visionary or an inventor?

152 **WYR** live the rest of your life in silence using only sign language and handwriting or have to sign everything you want to say forever?

153 **WYR** be a personal chauffeur for multiple celebrities and get inside scoops or get an investment for your own start up business?

154 **WYR** solve the world's most puzzling and difficult murder cases or commit the perfect murder, never to get caught?

155 **WYR** dye your hair the color you hate the most for a year or shave your head bald once?

156 **WYR** volunteer by reading books to sick kids at the hospital or by cooking for and feeding homeless people in shelters?

157 **WYR** be a secret agent with a dangerous and exciting life but no meaningful relationships or have a regular desk job, decent salary and healthy relationships?

158 **WYR** have a maid or personal chef for the rest of your life?

159 **WYR** retire early at 40 and live in an arctic climate or retire at 65 and live in a tropical climate?

160 **WYR** have a reputation for being a liar or for being promiscuous?

161 **WYR** have your significant other try and cook you a romantic meal or take you out to an expensive 5-star restaurant?

162 **WYR** bring back an extinct species or have a mythical creature exist?

163 **WYR** give up all technology for a week or give up only social media for a month?

164 **WYR** foster 10 kittens at one time but not have to keep any or adopt a baby llama and raise it as your pet?

165 **WYR** be trapped in a snowstorm for a week or try and outrun a tornado in your car?

166 **WYR** sketch or color in coloring books?

167 **WYR** go the extra mile or pull a rabbit out of your hat?

168 **WYR** have Chewbacca or Robin as your sidekick?

169 **WYR** channel surf or DVR all your shows?

170 **WYR** do 3-D or flat puzzles?

171 **WYR** caramel or mocha Frappuccino?

172 **WYR** pet sit or babysit?

173 **WYR** play keep away or tetherball?

174 **WYR** play marbles or jacks?

175 **WYR** eat Reese's Peanut Butter Cups or Reese's Pieces?

176 **WYR** eat chicken feet or pig knuckles?

177 **WYR** lose the ability to think quick or think under pressure?

178 **WYR** have lips the texture of a coconut or cat's tongue?

179 **WYR** trip and fall in front of an audience or in front of someone hot?

180 **WYR** have very fat arms with skinny legs or vice versa?

181 **WYR** transform into a vampire or be a vampire hunter?

182 **WYR** have a lion or a bear's roar?

183 **WYR** have chapped lips or chapped hands?

184 **WYR** smell like strawberries or peaches?

185 **WYR** be a minimalist or maximalist?

186 **WYR** live near railroad tracks or a busy airport?

187 **WYR** get bored easily or be easily entertained?

188 **WYR** your smartphone print 3-D images or all your photos instantly?

189 **WYR** eat a dead worm or one that's alive?

190 **WYR** get your head stuck in a fence or your body stuck in an airshaft?

191 **WYR** answer trick questions or brain teasers?

192 **WYR** have egg salad or tuna salad?

193 **WYR** see a merman or a female Yeti?

194 **WYR** have a high profile or lowkey job?

195 **WYR** fantasize about food or materialistic things?

196 WYR give up sex for a year or your cell phone for a year?

197 WYR attend mandatory counselling for 10 years or be assigned community service for 5 years?

198 WYR live life playing it safe but always wonder "what if" or always take chances wondering if it was worth it?

199 WYR have an advanced drone that spies on people globally or high-tech spy gear that can spy on your inner circle?

200 WYR spend your life overthinking every detail or make instant decisions without ever thinking?

201 WYR explore the Black Hole to see what's on the other side or try and live on another planet?

202 WYR be the best safe cracker in the world and use your skills for bad or be a highly respected "white-hat" hacker that uses your skills for good?

203 WYR be in charge of your own community theatre and have complete creative control or intern for a Hollywood director for a month?

204 WYR get revenge on your enemy or your ex?

205 WYR keep playing this "would you rather game" or go to sleep?

206 WYR live as a severe germophobic with horrible OCD or have multiple personalities that were all fun?

207 WYR spend the rest of your life as a circus clown or a street performer?

208 WYR lose your ability to feel any emotion or lose your taste buds?

209 WYR plan a wedding for your BFF or plan a major birthday party for your significant other?

210 WYR have your own TV show on Netflix or HBO?

211 **WYR** wear glasses the rest of your life whether you need them or not or give up pizza forever?

212 **WYR** go on an African Safari that is dangerous but once in a lifetime or an education exploration in Antarctica?

213 **WYR** experience the Matrix in real life or have a near death experience and get a glimpse of heaven?

214 **WYR** only ever be able to use sign language to speak or walk backwards the rest of your life?

215 **WYR** never celebrate your birthday again or never drink alcohol again?

216 **WYR** be an award-winning stunt actor and risk life and limb or work on a bomb squad and earn respect?

217 **WYR** have a picnic with a dying relative or a famous person you admire?

218 **WYR** read the journal of JFK or MLK Jr.?

219 **WYR** be attacked by a flock of seagulls or try and outrun a stampede of horses?

220 **WYR** play bagpipes in public while wearing a kilt (nothing under it) or play an accordion while wearing lederhosen at your old job/school?

221 **WYR** walk a tightrope 100ft in the air with no net or be shot out of a human cannon and try to hit a net?

222 **WYR** go to Comic-Con with all the meet and greet benefits you want or attend Coachella and sign on stage with your favorite performer?

223 **WYR** be best friends with a famous shoe designer or jean designer?

224 **WYR** be a popular investigative reporter for your local station and try to uncover truth or a famous *National Geographic* photographer who is highly published?

225 **WYR** throw out a pitch at the World Series or sing the National Anthem at the Super Bowl?

226 **WYR** be more logical or reasonable?

227 **WYR** have good karma or send bad karma to someone?

228 **WYR** eat raw cookie dough or cake batter?

229 **WYR** be called an airhead or dork?

230 **WYR** create a new mode of transportation or a new sports league?

231 **WYR** have the wisdom of Yoda or Confucius?

232 **WYR** dill pickles or sweet pickles?

233 **WYR** go to prom or homecoming again?

234 **WYR** feel justified or vindicated?

235 **WYR** find something valuable you lost or fix something valuable that was broken?

236 **WYR** see Oprah or Arnold Schwarzenegger as the next US President?

237 **WYR** sense danger or sense money?

238 **WYR** eat Cracker Jacks or Crunch 'N Munch?

239 **WYR** have swollen hands or feet?

240 **WYR** be physically weak or mentally weak?

241 **WYR** have Junior Mints or York Peppermint Patties?

242 **WYR** find a magic wand or a book of spells?

243 **WYR** eat a whole bag of marshmallows or whole jar of peanut butter at once?

244 **WYR** wear neckties or bow ties?

245 **WYR** wear hoops or studs?

246 **WYR** your friend yell at you or ignore you when they're mad at you?

247 **WYR** drive an amphibious vehicle or a hovercraft?

248 **WYR** meet in the middle or always get your way?

249 **WYR** wet your pants or vomit on your shoes in public?

250 **WYR** ride a gondola or a trolley?

251 **WYR** have a peg leg or hook for a hand?

252 **WYR** only speak in one liners or only quote movies?

253 **WYR** visit Wakanda or Zamunda?

254 **WYR** have unlimited gift cards to a clothing store or electronic store?

255 **WYR** have a jiggly face or a face that doesn't move?

256 WYR be covered in bees or spiders?

257 WYR go back to college and earn another degree for free or have the intern position of your dreams for a year?

258 WYR a live camera follow you around for a week and the world sees everything in real time as recorded or make a YouTube video confessing bad things you've done and apologizing to everyone you've ever hurt?

259 WYR pose nude for a class of art students or pose centrefold for a nude magazine?

260 WYR be a back-up singer for a famous recording artist or a headline act but only perform in clubs and bars?

261 WYR have your own epic tree house or your own CrossFit studio?

262 WYR hang out with Frankenstein or The Wolfman?

263 WYR help homeless people in your own city get off the street or help starving children in another country?

264 WYR get to design your own brand of chips or your own flavor of ice cream to be sold in stores?

265 WYR rock a mohawk hairstyle or wear platform shoes with every outfit for a year?

266 WYR have a self-cleaning house or a laundry fairy to take care of all your clothes?

267 WYR attend the last supper with Jesus or throw a dinner party for the current U.S. President?

268 WYR be the subject in a famous statue erected in your hometown or a famous painting with the popularity of Mona Lisa?

269 WYR bring back Michael Jackson or Prince from the dead?

270 WYR be a genie in a bottle or a wizard?

271 WYR wear pink every day for a year or never wear jewelry (includes wedding ring) again?

272 WYR design (unlimited budget) the scariest haunted house in the world or the most breathtaking winter wonderland?

273 WYR have a dream designer closet for your bedroom or have the *MasterChef* kitchen of your dreams in your current home?

274 WYR go a year without music or a year without TV?

275 WYR buy unlimited clothes from vintage boutiques or only a few pieces of clothes from an expensive department store? *A few pieces of clothes from an expensive dep. store.*

276 WYR give up coffee for a year or go without brushing your teeth for a year?
Coffee

277 WYR walk home in a downpour or be trapped in the cab ride from hell on your way home?
downpour

278 WYR marry someone who has a good career and is kind to you, that will take care of you, but you don't find them physically attractive or marry someone who you believe is your soulmate but always struggle financially? *Someone who has a good career that is kind and will take care of me.*

279 WYR attend a fun costume party with childish games or a fancy and mysterious masquerade ball full of snobbish people? *fun costume party*

280 WYR fart in an elevator full of strangers or belch loudly while giving an important presentation at work? *fart*

281 WYR have a lifetime supply of love or have a lifetime supply of gas for all of your cars?
lifetime supply of love

282 WYR have world peace or have any and all cancer types wiped out forever?
world peace

283 WYR never use toilet paper again or wear wrinkled clothes forever?
never use toilet paper

284 WYR be on house arrest forever or serve 10 years in solitary confinement?
house Arrest

285 WYR be the smartest person in the world or the richest? *Smartest cause then I would be rich*

286 **WYR** have a bowling alley or basketball court in your backyard?

bowling alley

287 **WYR** never wear shorts or socks again?

Socks

288 **WYR** get hit by water from a fireman's hose or from an elephant's trunk?

289 **WYR** be footloose and fancy free or just free?

Just free

290 **WYR** have a bunny's nose or tail?

tail

291 **WYR** have a *Maze Runner* or *Hunger Games* experience?

Hunger Games

292 **WYR** have ants in your pants or a grub worm in your ear?

Ants

293 **WYR** go back in time 1,000 years or go forward 1,000 years?

forward 1,000 yrs

294 **WYR** have a splinter you can't get out or a seed embedded in your gums?

295 **WYR** be a park ranger or a game warden?

296 **WYR** eat Jell-O made from baby spit or sugar cookies topped with dandruff?

Sugar cookies topped w/ dandruff

297 **WYR** pick your battles or fight all the battles that come your way?

298 **WYR** be scared of the number 13 or afraid of the dark?

299 **WYR** have an egg head or be a goober?

300 **WYR** get hypnotized when you look at the moon or sleepwalk when you hear a bell?

301 **WYR** smell like a sewer or raw onion?

Onion

302 **WYR** be competitive or commanding?

303 **WYR** drink powdered milk or can milk?

Powdered

304 **WYR** groom a cat with your tongue or brush your dog with your hairbrush?

brush my dog w/ my hairbrush

305 **WYR** eat ice cream topped pizza or ice cream topped with rabbit poop?

Pizza

306 **WYR** wear a scarf or gloves?

gloves

307 **WYR** shake things up or fly under the radar?

308 **WYR** stronger arms or legs?

arms

309 **WYR** never take your sunglasses off or never take your hat off?

Sunglasses

310 **WYR** only be allowed to speak in slang or never use slang words again?

speak in Slang

311 **WYR** lose your sense of smell or taste?

taste

312 **WYR** dream in 3-D or have fewer nightmares?

fewer nightmares

313 **WYR** climb Jack's beanstalk or fix Humpty Dumpty's cracked shell?

Fix HDs Shell

314 **WYR** see a cow jump over the moon or see the man on the moon?

Man on the moon

315 **WYR** get to a party late or too early?

too early

316 WYR drink out of a complete stranger's glass or eat your own booger?

317 WYR take a guarantee of $100,000 or compete in a spelling bee for a chance to win $100,000,000?

318 WYR trade places with a stray dog in your neighborhood or a kid being bullied in school for a day?

319 WYR the world sees your complete browser history without warning or pee on yourself in public?

320 WYR drink a cup of your significant other's spit or eat one live cockroach?

321 WYR make someone disappear for good by blinking or bring someone back to life by snapping?

322 WYR have the thrilling job of a storm chaser and risk dying or the curious job of a treasure hunter, scavenging shipwrecks for treasure that may not be?

323 WYR lose a leg but live until 90 or keep your legs and die at 65?

324 WYR get head to toe tattoos of your choosing or get really bad botched plastic surgery?

325 WYR own the real DeLorean or Batmobile?

326 WYR be an impactful and powerful Goodwill Ambassador or run for President of the United States?

327 WYR have 100 boxes of Girl Scout Cookies or 100 dollars right now?

328 WYR have unlimited music downloads for a lifetime or free massages for a year?

329 WYR volunteer for a kissing booth or be auctioned off on a date with the highest bidder, with all proceeds going to charity?

330 WYR be able to erase people's memory or predict their future?

331 WYR sleep in an igloo or teepee for a year?

332 WYR be able to analyze and translate every dream you have from the moment on or never have another bad dream again?

333 WYR try and escape being buried alive or escape a corn maze with a murderer on the loose?

money?!!

334 WYR give up your right to vote on anything ever again (this includes contests, political, etc.) or give up talking on a phone for 2 years?

335 WYR have cars that fly or pots of gold at the end of every rainbow?

336 WYR have a remote-controlled life you can pause, rewind and fast forward or never have to worry about weight gain or your health ever again?

337 WYR be stuck in an elevator or on a Ferris wheel for 24 hours?

338 WYR have an imaginary creature (only you can see) follow you around and talk to you or hear weird noises under your bed every night?

339 WYR know what heaven or hell looks like?

340 WYR never to be able to have kids (this includes adoption) or have 10 kids, both a mix of your own and adoption?

341 WYR find a dead body in your car or 50 live snakes?

342 WYR go without brushing your teeth for a year or have to use toilet water to brush your teeth for a week?

343 WYR have to outrun an active volcano erupting or outrun a tsunami making landfall?

344 WYR ride a bucking bull in a rodeo or be the rodeo clown who distracts the bull for the rider?

345 WYR blow your nose with sandpaper or use bubble wrap instead of toilet paper?

346 WYR have a talking bird or dancing turtle as a pet?

347 WYR have your biography written or your journal published?

348 WYR eat uncooked rice or uncooked macaroni?

349 WYR have milk in your tea or coffee?

350 WYR erase your past or change it?

351 WYR have your lips permanently pursed or injected with too much filler?

352 WYR eat a cinnamon stick or bay leaf?

353 WYR your body or your face age?

354 WYR have red or brown freckles?

355 WYR eat dirt or weeds?

weed? ♥!!

356 WYR lie in a bath of slime or dirty dish water?

357 WYR open your heart or protect it?

358 WYR date someone who will treat you right or who will spoil you?

359 WYR have lobster claws or hedge clippers for hands?

360 WYR lick a fire hydrant or a door handle for a busy store?

361 **WYR** shop on Black Friday or the day after Christmas?

362 **WYR** see a dancing polar bear or a fox that can twirl?

363 **WYR** never wear black or white again?

364 **WYR** keep a first aid kit or weapon in your car?

365 **WYR** play doubles or singles in tennis?

366 **WYR** have a long-distance or online relationship?

367 **WYR** fall in love with someone you've known your whole life or just met?

368 **WYR** play solitaire or go fish?

369 **WYR** drive on the wrong side of the road or drive double the posted speed limit?

370 **WYR** clone your pet or a family member?

371 **WYR** projectile vomit or diarrhea?

372 **WYR** witness the sky falling or it raining men?

373 **WYR** be Type A or B personality?

374 **WYR** live in *The Blair Witch Project* or *Paranormal Activity*?

375 **WYR** hula hoop with your neck or leg?

376 **WYR** stand on an ant pile for 5 minutes or near a swarming beehive for an hour?

377 **WYR** spend the night in a dumpster or a porta-potty?

378 **WYR** your crush see you pick your nose or hear you fart?

379 **WYR** have a wound on your body that hurts and never heals or a broken heart from a bad relationship that never mends?

380 **WYR** lead a walkout on your job for better work conditions or protest for a cause you believe in?

381 **WYR** know if someone is talking about you behind your back or see 10 years into your future life?

382 **WYR** take cold showers the rest of your life or never get more than 4 hours sleep at night ever again?

383 **WYR** have a nervous breakdown in public or take your anger out on the people closest to you?

384 **WYR** get sucker punched in the face by a stranger in public or have your BFF pull an embarrassing prank in front of all your friends?

385 **WYR** leave your current life and get 1 million dollars but never get to go back or stay as you are now?

386 **WYR** never be able to go to the beach again or live off grid for a year?

387 **WYR** be able to manipulate weather or speak to the dead?

388 **WYR** have your laugh sound like a hyena or a cow mooing?

389 **WYR** wear adult diapers the rest of your life or never wear underwear again?

390 **WYR** be an executioner on death row for a month or a crash test dummy for a day?

391 **WYR** take credit for something you didn't do or blame someone for something you did bad?

392 **WYR** begin each sentence with, "I am the greatest person in the world" or end each sentence with, "you suck?"

393 **WYR** get bit by a vampire or a dog with rabies?

394 **WYR** compete in *Survivor* or *The Amazing Race*?

395 **WYR** oink like a pig when someone talks about food or make kung-fu moves every time someone talks about music?

396 **WYR** have your taste buds on the bottom of your feet or sense of smell on the palm of your hands?

397 **WYR** fly a kite in a rainstorm or walk barefoot on hot coals?

398 **WYR** get motion sickness every time you run or green slime shoot out of your nose when you sneeze?

399 **WYR** put ketchup or ranch dressing on everything you eat?

400 **WYR** never be able to have a bank account again or never be able to own a business?

401 **WYR** have magic shoes that make you invisible or magic glasses that incinerate things?

402 **WYR** spend a day in the life of someone you envy to see their truth or a homeless person that will make you appreciate your life more?

403 **WYR** wear a turban for a year or grow your hair as long as you could for a year, then shave it off?

404 **WYR** hear conversations in heaven or be a fly on the wall in someone's house of your choosing?

405 **WYR** get in the ring and fight Muhammed Ali or Floyd Mayweather?

406 **WYR** suck a stranger's thumb or pick your mom's nose?

407 **WYR** have a poodle or pug?

408 **WYR** see lemurs or aardvarks at your zoo?

409 **WYR** take a photo with Santa or the Easter bunny?

410 **WYR** live in denial or shame?

411 **WYR** play with Silly Putty or Play-Doh?

412 **WYR** have blurry vision or be colorblind?

413 **WYR** make amends or move on?

414 **WYR** microwave or stovetop popcorn?

415 **WYR** drink almond milk or soy milk?

416 **WYR** swim with dolphins or manatees?

417 **WYR** tour a wax museum or observatory?

418 **WYR** have a bubble bath or hot shower?

419 **WYR** be a long-distance runner or sprinter?

420 **WYR** encourage others or be generous?

421 **WYR** eat honey mustard or thousand island dressing?

422 **WYR** your ears be too small or too big?

423 **WYR** wear a fedora or beret?

424 **WYR** build sandcastles or boogie board at the beach?

425 **WYR** play Simon or Memory?

426 **WYR** never get a headache or stomach ache again?

427 **WYR** sleep on a pillow top or memory foam mattress?

428 **WYR** play hangman or tic-tac-toe?

429 **WYR** be the first person to explore a planet or take an experimental drug?

430 **WYR** be near sided or far sided?

431 **WYR** head bang or slam dance?

432 **WYR** have Velcro hands or feet?

433 **WYR** sleep in a spooky attic or an eerie basement?

434 **WYR** play Chinese checkers or chess?

435 **WYR** have your own secret handshake or secret language?

436 WYR have webbed hands or webbed feet?

437 WYR spend the rest of your life living and traveling the world in a RV or inherit a castle but never get to leave it?

438 WYR wear a onesie 24/7 for a year or a horse head costume for a month straight?

439 WYR only be allowed to shop online and not in stores forever or only in stores and never shop online again?

440 WYR be super attractive and fight off people coming on to you or be average looking and have an attractive spouse people are always coming on to?

441 WYR eat bacon flavored desserts or sweet flavored meats?

442 WYR run the fighting gauntlet like in the movie *Gladiator* or fight street gangs like in the movie *Warriors*?

443 WYR be a high-powered attorney but only represent crime bosses and hitmen or a prosecutor who puts them away?

444 WYR suck a worm flavored lollipop or lick snail flavored ice cream?

445 WYR have two left feet or your eyes in the back of your head?

446 WYR have an alarm clock that wakes you up to the smell of breakfast or one that greets you with positive affirmations?

447 WYR have your child be popular in school but have a C average or not be popular but have straight A's?

448 WYR own a horse with wings like Pegasus or a talking dog with human intelligence?

449 WYR Godzilla or King Kong be real?

450 WYR have suction cup like hands or wheels on your feet?

451 **WYR** have James Bond's gadgets or Batman's toys?

452 **WYR** be an assassin or a spy?

453 **WYR** have a birthday bash at a mansion with celebrity guests and no family or on a private luxury yacht with friends and family only?

454 **WYR** your eyes have night vision capabilities or your ears have sonar capabilities?

455 **WYR** ask your significant other to give up their career for your dream or you give up your career for theirs?

456 **WYR** catch a home run ball from your favorite baseball player or have dinner with your favorite sports team?

457 **WYR** create a documentary film where you go undercover inside a cult or the most isolated tribe in the world?

458 **WYR** date a person convicted of murder or a person convicted of running a Ponzi scam?

459 **WYR** have one glass eye or one robotic prosthetic arm?

460 **WYR** dress up like Santa and scare kids at Christmas or dress up like cupid and terrorize couples on Valentine's Day?

461 **WYR** have severe bad dreams for a year that give you anxiety or survive a bank robbery but get PTSD?

462 **WYR** be put in a quality elderly care home when you get older or live alone and risk dying alone?

463 **WYR** eat earthworms or dung beetles?

464 **WYR** bring back Elvis or Michael Jackson?

465 **WYR** live on Twinkies and Spam or raw fish and moldy cheese for a year?

466 **WYR** have an infestation of mice or flying cockroaches in your home?

467 **WYR** have the power to cast spells on people or cure the sick?

468 **WYR** find the Fountain of Youth or find the Fountain of Truth to answer all your life's questions?

469 **WYR** dine with royalty or geniuses?

470 **WYR** try and survive an avalanche or a mudslide?

471 **WYR** give up fried foods or sugar forever?

472 **WYR** have a funny tombstone or a heartfelt memorial resting place?

473 **WYR** rap onstage with Eminem or Jay-Z?

474 **WYR** use lotion that has bug guts in it or shampoo where the main ingredient is pig blood?

475 **WYR** have skin like a snake or teeth like a crocodile?

476 **WYR** have more hours in your day or an extra day in the week?

477 **WYR** never see another sunset or sunrise?

478 **WYR** burp every time you kiss someone or laugh loudly every time you meet a new person?

479 **WYR** live in the tallest penthouse in New York City or a beach house right on the beach in Malibu?

480 **WYR** die before or after your spouse?

481 **WYR** live in a socialist or totalitarian society?

482 **WYR** be seated on a plane next to a screaming baby or someone with bad body odor?

483 **WYR** have Albert Einstein as a teacher or Stephen Hawking as a mentor?

484 **WYR** collaborate on a book with Stephen King or J.K. Rowling?

485 **WYR** spend life fighting for what you believe in or settle for a quieter, peaceful life but make no impact in the world?

486 **WYR** have to read everything in braille or script that you have to decode?

487 **WYR** enter a secret portal to an alternate universe or secret door to the afterlife?

488 **WYR** trek through a snow-covered wilderness or desolate desert?

489 **WYR** be a private detective or gossip columnist?

490 **WYR** be on the cover of *People* or *TIME* magazine?

491 **WYR** play Spin the Bottle or truth or dare every day?

492 **WYR** live in a cabin deep in the swamp or a tree house in the jungle?

493 **WYR** be an experimental patient for cryogenics or for human cloning?

494 **WYR** have your most embarrassing photos posted on Facebook or accidentally fall in public and the video go viral?

495 **WYR** face the Grim Reaper or Freddy Kruger?

496 **WYR** munch on trail mix or granola bars when you're hiking?

497 **WYR** soak in a hot spring or float down a lazy river?

498 **WYR** use a canteen or a thermos?

499 **WYR** wear low tops or high tops?

500 **WYR** do crosswords or word search puzzles?

501 **WYR** play Yahtzee or Scrabble?

502 **WYR** find a kindred spirit or soulmate?

503 **WYR** have a trundle bed or pullout sofa bed?

504 **WYR** ration your food or water in the event of an emergency?

505 **WYR** have a telescope or microscope?

506 **WYR** fight an octopus or squid underwater?

507 **WYR** be intrusive or obtuse?

508 **WYR** collect bottle tops or trading cards?

509 **WYR** play team sports or an individual event?

510 **WYR** have frost bite on your nose or toes?

511 **WYR** snuggle a sloth or kiss a koala?

512 **WYR** do tricks with a hacky sack or yo-yo?

513 **WYR** be able to balance on your head or fingertip?

514 **WYR** join the Army reserves or the Coast Guard reserves?

515 **WYR** play the fiddle or cello?

516 **WYR** be able to change a person's mood or mind?

517 **WYR** your home smell like fresh baked bread or fresh baked cookies?

518 **WYR** assemble model trains or planes?

519 **WYR** listen to a lullaby or nursery rhymes?

520 **WYR** get a haircut from a toddler or have your thumbnails pulled off by pliers?

521 **WYR** have team spirit or good sportsmanship?

522 **WYR** tape your eyes open or your nose back?

523 **WYR** defend yourself with a hockey stick or baseball bat?

524 **WYR** nature have more flowers or trees?

525 **WYR** use a backpack or satchel?

526 WYR eat a small can of dog food or a bowl of cereal with spoiled milk?

527 WYR be covered in flies or maggots?

528 WYR tour a slaughterhouse where animals die or sit in on an execution?

529 WYR have autographed memorabilia from someone famous still alive or someone who is already dead?

530 WYR have a poem or a song written about you?

531 WYR have your life pattern a *Choose Your Own Adventure* book or a cheesy romance novel?

532 WYR plant trees or clean up trash on the side of the roads for Earth Day?

533 WYR have eyes like a frog or a tongue like a snake?

534 WYR have an adventure like Red Riding Hood or Goldie Locks?

535 WYR have neighbors that party all the time or ones that snoop and spy on you?

536 WYR die with a guilty conscience or confess to your family and have their opinion of you change?

537 WYR go into business with family or someone you respect?

538 WYR be trained in martial arts or boxing?

539 WYR your best friend break a promise or your significant other lie to you?

540 WYR get your heart broken but learn a lesson or break someone's heart and feel guilty?

541 **WYR** have a bad case of agoraphobia or photophobia?

542 **WYR** live a short life but die a hero or live a long time but people think you're a coward?

543 **WYR** date a psychopath or sociopath?

544 **WYR** have a physical disfiguration or a mental illness?

545 **WYR** have breakfast for dinner or pizza for breakfast every day for a year?

546 **WYR** eat pigs' feet or chicken feet?

547 **WYR** go without electricity or running water for a week?

548 **WYR** attend a celebrity séance or a book reading with your favorite author?

549 **WYR** eat 5 of the hottest peppers in the world or a stew made with crickets and grubworms?

550 **WYR** find a new species or a new planet?

551 **WYR** get caught internet stalking your ex or accidentally send a nude pic to your mom?

552 **WYR** know all your parent's secrets or all the skeletons in your significant other's closet?

553 **WYR** be guaranteed a spot in heaven but you must die tomorrow or die when it's your time and pray you get a place in heaven?

554 **WYR** go back in time and meet someone you admire from history or go back and meet some of your first ancestors?

555 **WYR** be roasted by comedian Kevin Hart or Sara Silverman?

556 **WYR** live in an area where there are lots of tornadoes or earthquakes?

557 **WYR** apologize more or argue less?

558 **WYR** eat soggy vegetables or stale chips?

559 **WYR** deep dish or thin crust pizza?

560 **WYR** crush a snail shell with your teeth or scale a fish with your fingernails?

561 **WYR** always eat dessert first or skip dessert?

562 **WYR** wear shackles or a strait jacket for 48 hours?

563 **WYR** clean 10 dirty toilets or wash 5 piles of dirty dishes?

564 **WYR** read a book or listen to an audio book?

565 **WYR** watch football or the Macy's parade on Thanksgiving?

566 **WYR** have gnats in your drink or a fly in your food?

567 **WYR** have Frosted Flakes or Raisin Bran?

568 **WYR** be lactose intolerant or have a gluten allergy?

569 **WYR** be more independent or more reliable?

570 **WYR** try Rolfing or cupping?

571 **WRY** play pool or bowling?

572 **WYR** have strobe lights or a disco ball at your next party?

573 **WYR** get a broken eye socket or broken jaw?

574 **WYR** have IHOP or Waffle House?

575 **WYR** have your mom's cooking or your grandma's cooking?

576 **WYR** have long stem roses or tulips?

577 **WYR** have the *Prom Night* or *Carrie* experience?

578 **WYR** try to crack a coconut or a safe?

579 **WYR** have Wheat Thins or Triscuits?

580 **WYR** always know what you're getting for Christmas or be surprised?

581 **WYR** manage your emotions or manage your stress level?

582 **WYR** have an umbrella or rain boots in a downpour?

583 **WYR** cross paths with a wicked scarecrow or sinister raven?

584 **WYR** only have a tent or sleeping bag when camping?

585 **WYR** use a map or a compass when traveling?

586 **WYR** sleepwalk for a year or be in a coma for a month?

587 **WYR** never be able to use GPS ever or never take another elevator again?

588 **WYR** star in one season of a reality TV show or be an extra in at least 50 movies?

589 **WYR** meet Leonardo da Vinci or Mother Teresa?

590 **WYR** have unlimited storage space on your smart phone or laptop?

591 **WYR** your mom or your boss get a copy of every text you get?

592 **WYR** get dentures or wear braces on your teeth the rest of your life?

593 **WYR** look at the browser history of your significant other or your boss?

594 **WYR** change your first name to a name you hate or get a small tattoo on your face?

595 **WYR** be locked in a room with someone you hate or Pennywise the clown?

596 **WYR** have a pet porcupine or pet skunk?

597 **WYR** have a meme go viral on social media of your worst facial expression or get banned from YouTube indefinitely?

598 **WYR** contract a condition like Benjamin Button or live with leprosy?

599 **WYR** have Morgan Freeman narrate your life out loud for everyone to hear or have a theme song played whenever you walk?

600 **WYR** be kidnapped by your ex or your current significant other's ex?

601 **WYR** learn dancing from Channing Tatum or Jabbawockeez?

602 **WYR** have an adventure with Bear Grylls but be forced to drink your own pee or travel to crazy destination and eat bizarre food with Andrew Zimmern?

603 **WYR** have a photographic memory or heightened senses?

604 **WYR** go trick-or-treating with Leatherface or Jason Voorhees?

605 **WYR** have to grow, hunt and kill your own food or eat only Taco Bell for a year?

606 **WYR** only bathe in rainwater or never use deodorant?

607 **WYR** walk around bare feet with no shoes for a year or wear clown makeup every day for a year?

608 **WYR** lose your ability to fall in love or your ability to discern right and wrong?

609 **WYR** have a secret admirer or be a secret admirer?

610 **WYR** have to wear a shirt every day that says, "I farted" or "I'm with Stupid?"

611 **WYR** swim in a tank full of piranhas or electric eels?

612 **WYR** your children or significant other be punished for the mistakes you make?

613 **WYR** be sucked into a virtual reality or live on the moon?

614 **WYR** stay in a different hotel each night for a year or have to be home by midnight forever?

615 **WYR** be stuck inside *Mario Bros World* or the *Grand Theft Auto* video game?

616 **WYR** have long nose hair or long ear hair?

617 **WYR** never wear shoes or underwear?

618 **WYR** talk your way out of a fight or fight your way out of a kidnapping?

619 **WYR** lick every inanimate object you see or be licked by every living thing you see?

620 **WYR** be able to eat food that's only free or drink only rainwater?

621 **WYR** kiss a dog that just licked themselves or a cat that just ate a rat?

622 **WYR** work as a urologist or a crime scene cleaner?

623 **WYR** milk a cow or milk a snake?

624 **WYR** forget how to speak or walk?

625 **WYR** run in a human hamster wheel or poop in a human litter box?

626 **WYR** take a window seat or aisle seat on a plane?

627 **WYR** crack your knuckles or pop your back?

628 **WYR** have your own bouncy house or waterslide?

629 **WYR** spend Christmas in Whoville or the North Pole?

630 **WYR** step on a nail or shut your hand in a door?

631 **WYR** forget how to spell or add?

632 **WYR** be able to move objects with your mind or make them disappear with a clap?

633 **WYR** eat Tic Tacs or Mentos?

634 **WYR** have skin like a cactus or pineapple?

635 **WYR** jump in a pile of leaves or snow?

636 **WYR** lick the puss out of a popped zit or busted blister?

637 **WYR** sleep with only a sheet or only a blanket?

638 **WYR** blow up 100 balloons or lick 500 envelopes?

639 **WYR** faint when you see blood or scream when you see your reflection in a mirror?

640 **WYR** be an average person now or a king/queen living centuries ago?

641 **WYR** have giraffe legs or flamingo legs?

642 **WYR** smell fresh laundry or fresh cut grass?

643 **WYR** eat a banana peel or bird feather?

644 **WYR** eat ice cream or pudding with your hands?

645 **WYR** wear a shirt made of snakeskin or hat made from squirrel tail?

646 **WYR** get divorced 3 times or never get married?

647 **WYR** have an affair with an influential politician or a powerful attorney?

648 **WYR** play one on one basketball with Michael Jordan or Kobe Bryant?

649 **WYR** have high tea with Sharon Osbourne or the Queen of England?

650 **WYR** go a year missing your two front teeth or talk with a bad lisp forever?

651 **WYR** attend a Halloween party hosted by mad scientists or cannibals?

652 **WYR** drive a VW bug painted every color of the rainbow or dress like the 70s era for a year?

653 **WYR** have a significant other that's too flirty or one who complains too much?

654 **WYR** get compliments on your intelligence or looks?

655 **WYR** be handcuffed to the most annoying person you know for 24 hours or go camping with someone who likes you, but you don't like back?

656 **WYR** cut to the front of any line anywhere you go or have front row parking everywhere you go?

657 **WYR** allow your body to host an alien species until its born or live with parasites forever?

658 **WYR** make one person's dreams come true or buy lunch for 10 starving kids?

659 **WYR** cry tears of blood or have a cold the rest of your life?

660 **WYR** have your own jetpack or get the chance to travel at the speed of light?

661 WYR have a *50 Shades of Gray* romance or a *Pretty Woman* love story?

662 WYR be a juror on a famous court case and get a book deal but put your family in danger or survive a murder for hire plot and get to interview with Oprah?

663 WYR have a movie made about your life and star in it or direct a movie about your family's life?

664 WYR have hair on your back or go completely bald?

665 WYR have your house smell like a skunk or rotting trash?

666 WYR walk on scorpion infested land or swim through jellyfish infested water?

667 WYR eat a taco made of bugs or weird animal parts?

668 WYR lick the bottom of your shoes or your toilet seat?

669 WYR be great at sports or at trivia?

670 WYR live under a bridge or in a condemned building?

671 WYR get too little sleep or too little to eat daily?

672 WYR drink dirty dishwater or your own puke?

673 WYR your country goes to war again or battle a plague outbreak?

674 WYR live among the clouds or beneath the ocean?

675 WYR have your head be too big for your body or hands that are too small for your size?

676 WYR have looks that could kill or a killer look?

677 WYR avoid stupid people or annoying people?

678 WYR be braver or stronger?

679 WYR fix two of your friends up together or stay out of their love life?

680 WYR let sleeping dogs lie or let the cat out of the bag?

681 WYR steal someone's thunder or give them a taste of their own medicine?

682 WYR lie on your resume or a job application?

683 WYR get body slammed by a pro wrestler or kicked by an MMA fighter?

684 WYR eat celery with pimento cheese or carrot sticks with dip?

685 WYR be considerate or cunning?

686 WYR attend a bonfire or wine tasting?

687 WYR forget to wear deodorant or brush your teeth before your date?

688 WYR sleep all weekend or be out and about all weekend?

689 WYR be sharp as cheddar or cool as ice?

690 WYR squish a spider under your bare foot or have a frog pee on your head?

691 **WYR** be a referee or coach?

692 **WYR** have too many allergies or too many phobias?

693 **WYR** wrap everything you eat in bacon or slather it with butter?

694 **WYR** others hear your thoughts or see what's in your head?

695 **WYR** sleep on a waterbed or bunk bed?

696 **WYR** be a drill sergeant or run a boot camp?

697 **WYR** break up a fight or record it and post it to YouTube?

698 **WYR** be all knowing or all seeing?

699 **WYR** always leave the party early or always be the last to leave?

700 **WYR** make more money or do more meaningful work?

701 **WYR** live in a house with no roof or no windows?

702 **WYR** use a dirty sock or your hand as toilet paper?

703 **WYR** count the stars in the sky or all the leaves on a tree?

704 **WYR** eat hummus or tzatziki?

705 **WYR** eat hoagies or gyros?

706 **WYR** have children when you're too young or too old?

707 **WYR** snoop through your enemy's phone or snoop around their home?

708 **WYR** marry someone 20 years older that has everything you want in a spouse or date someone much younger than you who never wants to get married?

709 **WYR** spend a month changing diapers at a nursing home or cleaning out animal cages at the zoo?

710 **WYR** wear a bathing suit to a formal event or wear ugly formal clothes to a party?

711 **WYR** borrow money from a loan shark or the biggest gossip you know?

712 **WYR** explore the Grand Canyon in the dark or the Amazon Rainforest during a rain storm?

713 **WYR** test drive the world's fastest car or the world's most luxurious car?

714 **WYR** tour the food scene in Paris or Italy?

715 **WYR** be frozen at your current age forever or give your parents 10 extra years of life?

716 **WYR** be able to run super-fast or have the strength of 10 humans?

717 **WYR** experiment with voodoo or fortune telling?

718 **WYR** have your own private island or your own airline?

719 **WYR** spend the night at the White House or Buckingham Palace?

720 **WYR** eat coffee flavored everything or put jelly beans on everything you eat for a year?

721 WYR have a mullet or super long dreads?

722 WYR solve the Jack the Ripper murder or solve the Zodiac murders?

723 WYR not have any friends or have friends that you don't trust?

724 WYR live in a home made of tin cans or popsicle sticks?

725 WYR never be able to use a credit card again or pay for food only using pennies?

726 WYR have Jurassic Park be real or have more Disney Worlds be built?

727 WYR battle Moby Dick or Jaws?

728 WYR have no eyebrows or an extra finger?

729 WYR watch 365 days of horror movies or rom coms?

730 WYR have a child that was a bully or very rebellious?

731 WYR break all your bones in a car crash but heal or not get injured in the crash but the person riding with you die?

732 WYR drive an 18-wheeler the rest of your life or live off what you make panhandling on the streets?

733 WYR be Captain of the Death Star or Enterprise?

734 WYR have a job that you're over qualified for or under qualified for?

735 WYR be a journalist for *Rolling Stone* or *New York Times*?

736 **WYR** jump to conclusions or make assumptions?

737 **WYR** feed a mouse to a snake or a bird to a cat?

738 **WYR** lick a bone your dog's been chewing on or wipe your car windshield with your cheek?

739 **WYR** have eagle talons or vampire fangs?

740 **WYR** battle pirates or vikings?

741 **WYR** rescue baby turtles or baby otters?

742 **WYR** your kids take the bus to school or you drive them?

743 **WYR** ride the scariest waterslide or tallest ride at an amusement park?

744 **WYR** get locked out of your house or your car?

745 **WYR** your fingers always feel sticky or your throat always feel itchy?

746 **WYR** your feet always feel on fire or frozen?

747 **WYR** BASE jump or jump out of an airplane over water with no parachute?

748 **WYR** believe in ghosts or aliens?

749 **WYR** have your snot thick like tree sap or eye boogers like applesauce?

750 **WYR** have a brush with death or get a fishing lure caught on your face?

751 **WYR** live with no regrets or live carefree?

752 **WYR** listen to the same song 24-hours on repeat or watch the same movie for a week?

753 **WYR** have more charm or more character?

754 **WYR** build a fort out of nature or sheets?

755 **WYR** your heels or palms itch?

756 **WYR** have a hairy back or hairy stomach?

757 **WYR** eat a fly or moth?

758 **WYR** be a friendly ghost or a vengeful phantom when you die?

759 **WYR** drink a slug shake or leech smoothie?

760 **WYR** eat Hot Tamales the candy or actual tamales?

761 **WYR** listen to someone's confession or problems?

762 **WYR** play the banjo or tambourine?

763 **WYR** break dance every time you hear a car horn or twerk every time you hear birds chirp?

764 **WYR** have thumb tacks on the end of your fingers or paperclips on the end of your toes?

765 **WYR** know a secret that could get you killed or accidentally lose a million-dollar idea?

766 **WYR** lie to a priest or lie under oath?

767 **WYR** die before the world ends or die watching the world come to an end?

768 **WYR** pick your lotto numbers from your fortune cookie or from your horoscope?

769 **WYR** be kicked in the head by a mule or hit in the head by a foul ball at a baseball game?

770 **WYR** get in a water balloon fight where the balloons were filled with sewer water or cat urine?

771 **WYR** learn ballroom dancing or hip-hop dancing?

772 **WYR** eat BBQ road kill or opossum stew?

773 **WYR** always have peace in your relationships or always win every argument you're in?

774 **WYR** wear cowboy boots every day for a month or ballet slippers for a week?

775 **WYR** abolish animal testing forever or make humans go through the same tests animals do?

776 **WYR** be able to talk to angels or see demons around you?

777 **WYR** be able to sleep your way to your dream career in 2 years or earn it on your own in 10 years?

778 **WYR** free all the innocent people in jail or lock up all the criminals still out on the street?

779 **WYR** suffer from paranoia or be very superstitious to the point of crazy?

780 **WYR** attempt to swallow a sword or fire?

781 **WYR** hang around rude people who were honest or nice people who were completely fake?

782 **WYR** make up for lost time with someone or erase a painful memory?

783 **WYR** hack a celebrity's Twitter and go crazy posting or hack your enemy's Facebook and get revenge?

784 **WYR** be too overweight or too anorexic?

785 **WYR** creep everyone out you meet or be creeped out by everyone you meet?

786 **WYR** go spelunking or try hardcore parkour?

787 **WYR** drive in a NASCAR race or be a jockey at the Kentucky Derby?

788 **WYR** be trapped in a runaway train or a falling elevator?

789 **WYR** visit a sex shop with your grandmother or spend a month in a convent?

790 **WYR** zipline through fire or run through quicksand?

791 **WYR** only be allowed to watch animated movies or only black and white movies?

792 **WYR** be a victim of catfish or be the one catfishing a person?

793 **WYR** sacrifice your integrity or pride for someone you love?

794 **WYR** risk your child's college tuition on a "sure thing" investment and possibly make millions or only afford to send them to community college?

795 **WYR** humiliate your significant other or your parents?

796　**WYR** have corn on the cobb or off the cobb?

797　**WYR** live in the moment or obsess about the future?

798　**WYR** find a dinosaur egg or lost treasure from the Ming Dynasty?

799　**WYR** everyone think you're fake or think you're shallow?

800　**WYR** go ice fishing or deep-sea fishing?

801　**WYR** write with your eyes closed or with your nondominant hand?

802　**WYR** race wheel chairs or motorized chairs?

803　**WYR** eat glue or pencil erasers?

804　**WYR** look through the gym locker of someone you find hot or have them spot you a set?

805　**WYR** get your hand stuck in a meat grinder or blender?

806　**WYR** have endless adrenaline rushes or endless access to knowledge?

807　**WYR** dress to impress or dress for success?

808　**WYR** get poison ivy in your ear or in your nose?

809　**WYR** get a rope burn or splattered with hot grease?

810　**WYR** have your sofa covered in pet hair or a noisy plastic cover if you can't take either off?

811 **WYR** always spit or drool when you talk?

812 **WYR** always be thankful or mindful?

813 **WYR** have your spouse or your child be ashamed of you?

814 **WYR** be candid or cutthroat?

815 **WYR** have your hairline move back two inches or all your teeth be discolored?

816 **WYR** have something invisible attacking your funny bone or your eardrum?

817 **WYR** accidentally laugh loudly at a funeral or fart while giving a speech at a wedding?

818 **WYR** live in a humid or dry climate?

819 **WYR** have ear wax as big as corn flakes or boogers as big as Cheerios?

820 **WYR** split your lip or stub your toe?

821 **WYR** bite your tongue or always speak what's on your mind?

822 **WYR** always have an itch you can't scratch or have a thirst you can't quench?

823 **WYR** always feel bloated but can't burp or always feel like sneezing but never sneeze?

824 **WYR** your yawn sound like a lawnmower or your cough sound like a seal barking?

825 **WYR** people call you boring or a slacker?

826 **WYR** ride in a self-driving car you can't control or drive the smallest car in the world for free?

827 **WYR** suffer from a tooth ache or ear ache all day?

828 **WYR** people envy you or admire you?

829 **WYR** be the victim of a carjacking or identity theft?

830 **WYR** have money problems or health issues?

831 **WYR** inherit money or property?

832 **WYR** discover the unknown or explore the familiar?

833 **WYR** have a flower of the month or dessert of the month subscription?

834 **WYR** eat salads or drink smoothies every day for a week?

835 **WYR** turn in a duffle bag full of money to the cops or keep it and risk karma catching up with you?

836 **WYR** donate a kidney or bone marrow?

837 **WYR** have more patience or motivation?

838 **WYR** get to create a local law where you live or create a bill that could be voted on by congress?

839 **WYR** lose all the photos you've ever taken on your smart phone or have your identity stolen?

840 **WYR** eliminate AIDS or influenza from the planet?

841 **WYR** the world had one government that is all a democracy or everything stay as it is now?

842 **WYR** be in a Taylor Swift or Beyoncé music video?

843 **WYR** get premature gray hair or have terrible ear hair?

844 **WYR** enter a badminton or ping pong tournament for a chance to win money?

845 **WYR** be inside an Alfred Hitchcock movie thriller or an Agatha Christie short story mystery?

846 **WYR** attend group therapy for support or have one on one counselling for privacy?

847 **WYR** own an experimental robot dog or experimental drug for heightened intelligence?

848 **WYR** have a career as an ATF agent or U.S. Marshal?

849 **WYR** have a good job with tons of benefits but boring or a totally fulfilling job with no benefits?

850 **WYR** have an EPIC bachelor/bachelorette party and average wedding or vice versa?

851 **WYR** buy a radio network or a publishing house?

852 **WYR** go back in time and prevent Chernobyl or the Holocaust?

853 **WYR** have your hair turn into snakes like Medusa when you lie or grow horns like the devil when you hurt someone?

854 **WYR** be the most trusted sidekick of Billy the Kid or Al Capone?

855 **WYR** cuddle a koala bear or baby panda bear?

856 **WYR** have an appealing swagger or a style people try to copy?

857 **WYR** have a real live Winnie the Pooh or Paddington Bear?

858 **WYR** be controversial or unpopular?

859 **WYR** never use Snapchat or Periscope ever again?

860 **WYR** eat toilet paper or notebook paper?

861 **WYR** accidentally walk into a snake pit or wasps' nest?

862 **WYR** drink water with a dead rat in it or drink your own urine when you're dehydrated?

863 **WYR** walk like a runway model or John Travolta's character Tony Manero?

864 **WYR** have a mustache that can never be shaved or an extra tongue?

865 **WYR** fall asleep during your wedding ceremony or get lost on your honeymoon?

866 **WYR** be a hostage negotiator or talk a jumper down off a ledge?

867 **WYR** have Donald Trump's hair or Jay Leno's chin?

868 **WYR** your voice sound like Gilbert Gottfried or Fran Drescher?

869 **WYR** eat dinner with your online stalker or your ex from your worst relationship?

870 **WYR** draw comic books or build robots?

871 **WYR** decorate a gingerbread house or make gingerbread cookies?

872 **WYR** slip and fall in public or have a bad public breakup?

873 **WYR** drink beer from a bottle or frosted mug?

874 **WYR** your dandruff look like granola or acne look like bacon bits?

875 **WYR** laugh like a howler monkey or hyena?

876 **WYR** your job offers a naptime or recess?

877 **WYR** be forced to work on the first computer or use the first cellphone ever made?

878 **WYR** have ugly artwork on your walls or no artwork at all?

879 **WYR** hear or move like a 90-year-old senior?

880 **WYR** give yourself a facial with a toilet brush or foot pumice stone?

881 **WYR** drink prune juice or tomato juice?

882 **WYR** choose your career or a family?

883 **WYR** smell like bleach or Listerine?

884 **WYR** get lost at sea or lost in the jungle?

885 **WYR** have a nosebleed that won't stop or live in a room that won't stop spinning?

886 **WYR** be a doctor for a famous sports team or a small village in Africa?

887 **WYR** live without air conditioning or hot water?

888 **WYR** go back and get to do high school all over again or have all your debt paid off?

889 **WYR** date someone you met online or someone your parents set you up with?

890 **WYR** fake your own death and get a new life or empty all your bank accounts and start over in a new country but still be allowed to contact people you know?

891 **WYR** eat food out of a trash can or eat food with mold all over it?

892 **WYR** find a fingernail or worm in your salad?

893 **WYR** get stung by a group of scorpions or stand on a fire ant mound for 10 minutes?

894 **WYR** be a conjoined twin or be born with polymelia?

895 **WYR** be interviewed by Barbara Walters or Howard Stern?

896 **WYR** be serenaded by Celine Dion or Barbara Streisand?

897 **WYR** go on a dating game show or online dating site to find love?

898 **WYR** the voice of your conscience sound like Bugs Bunny or Robert De Niro?

899 **WYR** have your own bee colony that produces honey or raise your own chickens that produce eggs?

900 **WYR** have more time for yourself or more sleep each day?

901 **WYR** be more creative or more intuitive?

902 **WYR** relive the worst day of your life or get sprayed by pepper spray and then hit by a stun gun?

903 **WYR** only have one friend the rest of your life or never be able to get divorced?

904 **WYR** have your own stylist and personal tailor or eat at any restaurant for free whenever?

905 **WYR** be served breakfast in bed daily or get an extra hour sleep daily?

906 **WYR** write greeting cards or obituaries for a living?

907 **WYR** consult an Ouija Board or Magic 8 Ball for answers to your questions?

908 **WYR** box a kangaroo or tussle with a moose?

909 **WYR** eat your favorite food covered in roly-polies or tree bark?

910 **WYR** rock a combover hairstyle or dress like Alice Cooper?

911 **WYR** find a four-leaf clover or a really old penny?

912 **WYR** ding-dong ditch 10 houses in your neighborhood or hang a "Congratulations" sign with balloons on your neighbor's door and video their reaction?

913 **WYR** eat a 10-year-old fruitcake still in its package or drink expired eggnog?

914 **WYR** start a rumor or spread gossip you overheard?

915 **WYR** learn how to send and decode Morse code or learn how to read braille?

916 WYR be protected from evil spirits or evil people?

917 WYR drive a 4-wheeler or dirt bike for fun?

918 WYR eat saltines or Ritz crackers?

919 WYR egg your least favorite teacher's car or someone who picked on you's head?

920 WYR stay at the Overlook Hotel or the Bates Motel?

921 WYR get an infected cut or ingrown toenail?

922 WYR be a fake psychic or sinister fortune teller?

923 WYR watch baby owls or baby penguins?

924 WYR be afraid to try new things or be so open minded that you never say no?

925 WYR skinny dip in the ocean or a neighborhood pool at night?

926 WYR wear V-neck or crew tees?

927 WYR always kill two birds with one stone or handle things one at a time?

928 WYR look for the silver lining or just go to sleep and wait for the day to be over?

929 WYR eat mangos or papayas?

930 WYR give up candy for Halloween or turkey for Thanksgiving?

931 **WYR** have a white Christmas or a tropical Christmas?

932 **WYR** have a pebble in your shoe or an eyelash in your eye you can never get out?

933 **WYR** stomp the yard or get into the groove?

934 **WYR** be a charmer or puppet master?

935 **WYR** be a dentist or podiatrist?

936 **WYR** get burned by a hot curling iron or boiling water?

937 **WYR** your eyebrows or arm hair come to life and dance every full moon?

938 **WYR** always maintain control or maintain order?

939 **WYR** seek the truth or pursue your dreams?

940 **WYR** have hammer toes or clubbed thumbs?

941 **WYR** dye your hair or shave in a public restroom?

942 **WYR** people be less obsessed with money or sex?

943 **WYR** only buy hybrid cars or never buy a hybrid?

944 **WYR** Photoshop or use filters on all your selfies?

945 **WYR** be questioned about your motives or your integrity?

946 **WYR** eat a spoonful of wasabi or one ghost pepper?

947 **WYR** own Darth Vader's helmet or Michael Jackson's "Thriller" jacket?

948 **WYR** attempt the cinnamon challenge or the saltine challenge?

949 **WYR** try and do a handstand while surfing or waterski with no skis?

950 **WYR** put flypaper on your hands and try to complete a normal day or stick your big toe in a mouse trap?

951 **WYR** try snake charming or get hypnotized?

952 **WYR** experience 40 days of rain or 40 days of darkness without sun?

953 **WYR** have a summer romance or spring fling?

954 **WYR** the disco era or flapper era come back around?

955 **WYR** walk through a river filled with leeches or snapping turtles?

956 **WYR** be trapped in a room with bats or rats?

957 **WYR** forgive someone who murdered someone close to you or have the ability to sentence them to death?

958 **WYR** have a roommate who was quiet and asocial or loud and obnoxious?

959 **WYR** live life with "no regrets" or "no what-ifs?"

960 **WYR** have a road trip with Donald Trump or O.J. Simpson?

961 **WYR** open your front door and see Jigsaw or Michael Myers?

962 **WYR** eat whole coffee beans or lemon seeds?

963 **WYR** lose your keys down a sewer drain or down an elevator shaft?

964 **WYR** sleep on a bed of rose thorns or bed of hay animals have slept on?

965 **WYR** have the ugliest plastic flamingos or the scariest troll garden gnomes in your front yard?

966 **WYR** live in a bright pink house or a house where the grass is never mowed?

967 **WYR** wake up in a dingy in the middle of the ocean alone or wake up bound and gagged in the back of a trunk?

968 **WYR** compete on *American Idol* or *The Voice*?

969 **WYR** be able to count your blessings or your money?

970 **WYR** enter a hot dog or a pie eating contest?

971 **WYR** be a good fighter or good lover?

972 **WYR** drink the best coffee in the world or sample the finest chocolate ever made?

973 **WYR** have perfect teeth or perfect hair?

974 **WYR** spend the night in Alcatraz or on the Island of the Dolls in Mexico?

975 **WYR** always get the latest smartphone for free or get free haircuts the rest of your life?

976 **WYR** see one of your parents having an affair or see your spouse having an affair?

977 **WYR** be the brunt of a joke or have people think you're a joke?

978 **WYR** be seen as an antagonist or protagonist?

979 **WYR** watch sci-fi or animated movies?

980 **WYR** eat chowder or chili?

981 **WYR** eat onion rings or onion strings?

982 **WYR** wear flannel or thermals in the winter?

983 **WYR** have a lighter load or an easier schedule?

984 **WYR** have tortilla chips with salsa or queso?

985 **WYR** be a drum major or cheerleader?

986 **WYR** nibble on fresh mozzarella or parmesan cheese?

987 **WYR** feel empowered or elated?

988 **WYR** use a dating app or a dating service?

989 **WYR** have a lazy coworker or a lazy spouse?

990 **WYR** have a walk of shame or see your nemesis do a walk of shame?

991 **WYR** people prejudge you or criticize you?

992 **WYR** spend New Year's Eve in the comfort of your own home with someone you love or in Times Square with strangers?

993 **WYR** be hands on or hands off when it comes to raising kids?

994 **WYR** play water polo or traditional polo?

995 **WYR** give someone flowers or a fruit basket for a gift?

996 **WYR** star in the musical *Grease* or *Wicked*?

997 **WYR** be a thrill seeker or truth seeker?

998 **WYR** be someone's hero or role model?

999 **WYR** aliens look like the ones from *ET* or *Independence Day*?

1000 **WYR** the planet has less pollution or less population?

1001 **WYR** be obsessed with taking and posting selfies to social media or have full-blown OCD?

1002 **WYR** live next door to a cemetery or snake farm?

1003 **WYR** become a brain surgeon or heart surgeon?

1004 **WYR** compete in a bartending competition like Cocktail or in the World Barista Championship?

1005 **WYR** be featured on *America's Most Wanted* or the side of a milk carton by accident?

1006 **WYR** accidentally break your arm or accidentally break your friend's arm?

1007 **WYR** explore Suicide Forest in Japan or the Gomantong Caves in Malaysia?

1008 **WYR** look for a needle in a haystack or put together a 40,000-piece puzzle?

1009 **WYR** come to your class reunion dressed like a baby wearing a diaper or the most hated celebrity in the world?

1010 **WYR** become a vigilante who targets people you feel need punishment or a superhero that saves innocent people from harm?

1011 **WYR** try volcano boarding at Cerro Negro or kayak down Niagara Falls?

1012 **WYR** participate in the Running of the Bulls in Spain or get in the Cage of Death in Australia?

1013 **WYR** spend the night in the Taj Mahal or the Vatican?

1014 **WYR** help release baby turtles back into the ocean or volunteer at an elephant sanctuary?

1015 **WYR** set a Guinness World Record or visit the North Pole?

1016 **WYR** drive a military tank or fly in a fighter jet?

1017 **WYR** take your friends up in a hot air balloon or host a dinner in the sky party?

1018 **WYR** drive the entire Route 66 or walk the Great Wall of China?

1019 **WYR** get a fish pedicure or caviar facial?

1020 **WYR** inherit a vineyard or a farm?

1021 **WYR** play with the Trans-Siberian Orchestra or the New York Philharmonic?

1022 **WYR** be good at 10 things or master one thing with excellence?

1023 **WYR** be in ten wills of different people you know or one will of a wealthy person you have only known a short time?

1024 **WYR** go to a job interview with really bad dandruff or bad breath?

1025 **WYR** hire someone for your company that you don't know but is very qualified or hire a close friend you trust?

1026 **WYR** be a door to door salesperson or sell used cars?

1027 **WYR** live in a world where plants can eat humans or birds attack humans?

1028 **WYR** find a rare artifact or find a forgotten time capsule from 50 years ago?

1029 **WYR** crack down harder on people texting and driving or drinking and driving?

1030 **WYR** write a book about a subject you hate or write a song for a singer you dislike?

1031 **WYR** have someone shoot an apple off your head via arrow or throwing knife?

1032 **WYR** be a widow or divorcee?

1033 **WYR** know the outcome of the choices you make in advance or leave everything to chance?

1034 **WYR** never wear tennis shoes or underwear again?

1035 **WYR** feel like you're slowly going insane or like you're losing your muscle strength?

1036 **WYR** jam with Lenny Kravitz or Jimi Hendrix?

1037 **WYR** people dress age appropriate or however they want?

1038 **WYR** heckle a bad comedian or roast an annoying co-worker?

1039 **WYR** be a team leader or a team player?

1040 **WYR** battle Lyme disease or Lupus?

1041 **WYR** join a cult or start your own religion?

1042 **WYR** get road rash from a fall or tangled in a barbed wire fence?

1043 **WYR** have a teacup pig or mini horse?

1044 **WYR** realize a blessing in disguise or have your cake and eat it too?

1045 **WYR** have a ceiling fan or oscillating fan?

1046 **WYR** be the devil's advocate or just be the devil on someone's shoulder?

1047 **WYR** sculpt ice or clay?

1048 **WYR** help a friend break out of jail or get out of a bad relationship?

1049 **WYR** be close friends with Snoop Dog or Dr. Dre?

1050 **WYR** co-host a morning show with Michael Strahan or Hoda Kotb?

1051 **WYR** eat a raw clove of garlic or a raw onion?

1052 **WYR** use your car's a/c or drive with the windows down?

1053 **WYR** work in a school or prison cafeteria?

1054 **WYR** attend a focus group or mock jury and get paid?

1055 **WYR** be the bearer of bad news or be the shoulder to cry on?

1056 **WYR** hear your soul speak or your heart sing?

1057 **WYR** disappoint your parents or your grandparents?

1058 **WYR** commit treason or espionage?

1059 **WYR** be less possessive or fight for someone you love?

1060 **WYR** say "I told you so" or "I love you?"

1061 **WYR** feel like you're floating or sinking?

1062 **WYR** drink flavored coffee or regular coffee?

1063 **WYR** confront your accuser or confront your demons?

1064 **WYR** never download any new apps or never upgrade your smart phone?

1065 **WYR** be a badass or a superstar?

1066 **WYR** eat bat guano or rat droppings?

1067 **WYR** play *Family Feud* with your family or go on *Fear Factor* with your BFF?

1068 **WYR** have a sensitivity to light or sound?

1069 **WYR** have to memorize the dictionary or The Holy Bible?

1070 **WYR** have a squirrel tail or chicken feathers on your arm?

1071 **WYR** have an exclusive membership to a private country club or VIP membership to a night club?

1072 **WYR** age visibly more rapidly but live longer or age very slowly but die younger?

1073 **WYR** have 365 days of snow or unrelenting drought like heat?

1074 **WYR** snore loudly or talk in your sleep about secrets?

1075 **WYR** only be able to watch movies that have ever won an Oscar or only listen to songs that have reached #1 on the charts?

1076 **WYR** only ride public transportation or only be able to Uber for 1 year?

1077 **WYR** be missing a thumb or have your right leg an inch shorter than the left?

1078 **WYR** have an annoying voice or googly eyes?

1079 **WYR** have more people at your wedding or funeral?

1080 **WYR** be a target of a hitman or your family be victims of ransom?

1081 **WYR** change your past or shape your future?

1082 **WYR** write the biography of someone famous you admire or someone famous who was very private?

1083 **WYR** participate in a dangerous college hazing or anonymously turn in your fraternity?

1084 **WYR** feel sleepy or hot all throughout your day?

1085 **WYR** meet someone who enchanted you or who made you curious about the world?

1086 **WYR** send a Voodoo doll or a horse head to your enemy?

1087 **WYR** have a circus act as a trapeze artist or lion tamer?

1088 **WYR** send more cyber bullies or cyber stalkers to jail?

1089 **WYR** take part in an experimental transplant or uncertain holistic remedies?

1090 **WYR** walk using orthopedic shoes or a cane?

1091 **WYR** learn from every mistake or never make another mistake?

1092 **WYR** throw up before each meal or burp for 30 minutes after each meal?

1093 **WYR** work less hours per day but work 7 days a week or work more hours a day but only work 3 days a week?

1094 **WYR** make your dying confession to your significant other or best friend?

1095 **WYR** play a card game of Poker or Go Fish, where your life depended on it?

1096 **WYR** talk about it or be about it?

1097 **WYR** your car smell like spoiled milk or a stinky burp?

1098 **WYR** have a hot shower or a hot meal?

1099 **WYR** carpool to work or ride the bus?

1100 **WYR** sip cappuccino or espresso?

1101 **WYR** have someone steal one of your ideas or steal your significant other?

1102 **WYR** learn from past mistakes or other's mistakes?

1103 **WYR** run outside or run on a treadmill?

1104 **WYR** snorkel or deep-sea dive?

1105 **WYR** eat spinach or broccoli?

1106 **WYR** feel haunted or cursed?

1107 **WYR** drink sweet tea or black coffee?

1108 **WYR** travel through time or space?

1109 **WYR** eat double stuffed or regular Oreos?

1110 **WYR** have a stalker like *Swimfan* or *Fatal Attraction*?

1111 **WYR** have a long neck or a long face?

1112 **WYR** attend a masquerade ball or formal party?

1113 **WYR** take the high road or get even?

1114 **WYR** kill them with kindness or add insult to injury?

1115 **WYR** wear cardigans or sweater vests?

1116 **WYR** eat steak tartar or sashimi?

1117 **WYR** have a penny for your thoughts or keep your thoughts to yourself?

1118 **WYR** eat an expired can of tuna or a fresh can of cat food?

1119 **WYR** feel obsolete or oppressed?

1120 **WYR** suffer a head or back injury?

1121 **WYR** have deep roots or deep insight?

1122 **WYR** eat sardine ice cream or rat droppings?

1123 **WYR** keep going back to the drawing board or change course?

1124 **WYR** cross a river full of crocodiles or piranhas?

1125 **WYR** lend a hand or lend money?

1126 **WYR** see all the wonders of the world or meet 10 inspiring people before you die?

1127 **WYR** your spouse died slowly from a disease but you'll have time to prepare or died without suffering from something unexpected?

1128 **WYR** have a scary dentist or a creepy doctor?

1129 **WYR** have mind control over a person or be able to manipulate time?

1130 **WYR** have access to billboards for free so you can speak to the world or have a 60 second commercial on a national network to spread a message?

1131 **WYR** have an endless supply of batteries or toilet paper?

1132 **WYR** have a serious fear of the dark or an exaggerated fear of heights?

1133 **WYR** convert to your fiancé's religion or have them convert to yours?

1134 **WYR** join a cult or a biker gang?

1135 **WYR** kiss someone with a tongue ring or braces?

1136 **WYR** live on the most gorgeous beach in a tent or live on a lake in a boathouse?

1137 **WYR** have an aggressive and dominant spouse or one who is meek and timid?

1138 **WYR** have bad acne your whole life or go deaf in one ear?

1139 **WYR** be a character in the last movie you saw or the last book you read?

1140 **WYR** steal a cop car or a firetruck?

1141 **WYR** think too much or think too little?

1142 **WYR** be King/Queen of England for a day and enjoy benefits therewith or have the ultimate super fan adventure of your dreams?

1143 **WYR** try and save your house from a flood or fire?

1144 **WYR** help a friend get off drugs or help a family member through a breakup?

1145 **WYR** boycott the government or a big company for better working conditions?

1146 **WYR** give up on falling in love or give up on a loved one who has gone astray?

1147 **WYR** other people be more compassionate or more forgiving?

1148 **WYR** get to decide the next protected species that cannot get hunted or create more animal protection rights in general?

1149 **WYR** live in fear or live in debt?

1150 **WYR** have ugly friends or friends that were gorgeous?

1151 **WYR** be stuck in a horrible traffic jam or be present when a riot breaks out?

1152 **WYR** be part of an exorcism or spiritual cleansing?

1153 **WYR** spend the day surfing in the ocean or surfing the web?

1154 **WYR** be single for the next 10 years or attend 20 weddings in a row without a date?

1155 **WYR** wear all black every day for a year or stay home every weekend for a year?

1156 **WYR** have the Statue of Liberty or Mt. Rushmore come to life?

1157 **WYR** trek the Sahara Desert or Frozen Tundra?

1158 **WYR** design ugly Christmas sweaters or ugly neck ties?

1159 **WYR** be a 911 operator or an ambulance driver?

1160 **WYR** put your foot in your mouth when you speak or never speak?

1161 **WYR** have a surreal moment or an epiphany?

1162 **WYR** have a lavender or rosemary garden?

1163 **WYR** be Liberal or Conservative?

1164 **WYR** be a prisoner in your mind or a slave to love?

1165 **WYR** use PayPal or Apple Pay?

1166 **WYR** have a funny or tasteful tombstone?

1167 **WYR** eat frozen grapes or frozen yogurt?

1168 **WYR** have unlimited cheats on your video games or any test you take?

1169 **WYR** your daughter look up to an athlete or actress?

1170 **WYR** make your own pizza at home or just buy it somewhere?

1171 **WYR** eat someone else's lunch at work or steal someone's lunch money?

1172 **WYR** use the other sex's restroom in an emergency or just pee outside?

1173 **WYR** always use the speaker phone option or never use speaker phone?

1174 **WYR** stop a burglary at your neighbor's house or not get involved?

1175 **WYR** live on Sesame Street or in Mister Roger's neighborhood?

1176 **WYR** dress sexy or modest?

1177 **WYR** be intimate with the lights on or off?

1178 **WYR** your spouse take your last name or you take theirs?

1179 **WYR** stop eating before you get full or when you get stuffed?

1180 **WYR** be faithful or sow your wild oats?

1181 **WYR** live in harmony or throw caution to the wind?

1182 **WYR** only brush your teeth in the morning or only at night?

1183 **WYR** live a lie to protect someone or be honest and hurt the ones around you?

1184 **WYR** spend the night in a psych ward or haunted motel?

1185 **WYR** win a vacation or money from a raffle ticket?

1186 **WYR** take a vow of silence for a month or break a wedding vow on purpose?

1187 **WYR** know how to fix your own car when it breaks down or have the money to buy a new car whenever one car breaks down?

1188 **WYR** go on a 30 day fast from food or from music?

1189 **WYR** experience the butterfly effect or live in a constant state of déjà vu?

1190 **WYR** be a museum curator or a librarian for a year?

1191 **WYR** women had their own football league within the NFL or women and men played baseball together in the MLB?

1192 **WYR** have a wanderlust spirit or a protagonist spirit?

1193 **WYR** discover oil or gold on your own land?

1194 **WYR** have dinner with King Henry VIII or Kim Jong Un?

1195 **WYR** only be able to watch Netflix or only watch local network TV?

1196 **WYR** be a part of Hawaii 5-0 task force or part of the A-Team?

1197 **WYR** Gotham or Atlantis be a real place?

1198 **WYR** hang out with the Rat Pack or the Brat Pack?

1199 **WYR** go fishing with Jeremy Wade or crabbing with the crew of *Deadliest Catch*?

1200 **WYR** be underestimated or under appreciated?

1201 **WYR** come across a bear or a mountain lion in the woods?

1202 **WYR** have a fruit tree or a nut tree in your backyard?

1203 **WYR** have the Transformers or Power Rangers to help defend earth?

1204 **WYR** be more soulful or more edgy?

1205 **WYR** have what's in a billionaire's safety deposit box at the bank or in their private home safe?

1206 **WYR** be a warrior for a cause or for yourself?

1207 **WYR** rob a money truck or a bank?

1208 **WYR** roller rinks or arcades make a comeback?

1209 **WYR** get rid of toll roads or first-class on airplanes?

1210 **WYR** donate your body to science or donate all your organs?

1211 **WYR** chase the legend of Bigfoot or search for mermaids?

1212 **WYR** cassette tapes or jukeboxes make a comeback?

1213 **WYR** steak or cake have zero calories?

1214 **WYR** be able to design a new flavor gum for a major brand or create your own candy bar for Nestle?

1215 **WYR** play in The Masters or at Wimbledon?

1216 **WYR** peak early or later in your life?

1217 **WYR** start a movement or a revolution?

1218 **WYR** have your martini straight up or on the rocks?

1219 **WYR** eat olives or pickles?

1220 **WYR** hot apple cider or hot chocolate on a cold winter's night?

1221 **WYR** reenact a stunt from *Jackass* or *Ridiculousness?*

1222 **WYR** Steve Harvey or Arsenio Hall introduce you before a performance?

1223 **WYR** compete on *Family Feud* or *Let's Make A Deal* with your significant other?

1224 **WYR** have gallstones or kidney stones?

1225 **WYR** be addicted to your phone or social media?

1226 **WYR** drink red wine or white wine?

1227 **WYR** go out every Friday or stay home every Friday?

1228 **WYR** sing the blues or sing for your supper?

1229 **WYR** eat buffalo wings or spare ribs with sauce when wearing a white shirt?

1230 **WYR** be a tour guide or a docent?

1231 **WYR** lose your voice or your sight?

1232 **WYR** find a treasure map or find a secret message that needs decoding?

1233 **WYR** live in the world of *Zelda* or *Mine Craft?*

1234 **WYR** coexist or not?

1235 **WYR** use Vaseline or Chapstick for your chapped lips?

1236 **WYR** wear stretchy pants or sweat pants?

1237 **WYR** wear tanks or tees?

1238 **WYR** get a personality or style upgrade?

1239 **WYR** be a skyscraper window washer or a dog walker picking up dog poo all day?

1240 **WYR** always follow the 5 second rule or no way?

1241 **WYR** attend a pool party or rooftop party?

1242 **WYR** have a song with good lyrics or good music?

1243 **WYR** step in animal poop or human vomit barefoot?

1244 **WYR** always be right or always get the last laugh?

1245 **WYR** post your blog on *Wordpress* or *Blogger?*

1246 **WYR** have a photographic memory or exceptional problem-solving skills?

1247 **WYR** be better at math or English?

1248 **WYR** have Biggie Smalls or Tupac back from the dead?

1249 **WYR** expose all the dirty cops or dishonest politicians?

1250 **WYR** get rid of sales tax on products and services or international duty taxes?

1251 **WYR** eat only using your fingers or chopsticks?

1252 **WYR** replace fortune cookie fortunes with dirty jokes or diet tips?

1253 **WYR** have the option to be born in a previous decade or a future decade that hasn't arrived yet?

1254 **WYR** celebrate Christmas or Halloween all year round?

1255 **WYR** explore the Great Barrier Reef or sunken Titanic?

1256 **WYR** gamble with your life savings or your parent's life savings?

1257 **WYR** have the latest fashion trends or the latest technology and software as it becomes available?

1258 **WYR** have a show on *Animal Planet* or the *Food Network*?

1259 **WYR** go on *Dancing with the Stars* or *American Ninja Warrior*?

1260 **WYR** be invisible for a day or be able to teleport for a day?

1261 **WYR** sing in a choir or quartet?

1262 **WYR** ban all GMO's or food dyes and colorings?

1263 **WYR** walk around covered in cake frosting or grape jelly?

1264 **WYR** attempt an emergency landing on a plane to prevent crashing or try and put out a raging fire in your home?

1265 **WYR** get busted for cheating on a test or cheating someone out of money?

1266 **WYR** be allergic to grass or dairy products?

1267 **WYR** spend the day cleaning fish or peeling potatoes?

1268 **WYR** have a bad spray tan or bad hair dye job?

1269 **WYR** more children get adopted and find families or more starving children get fed?

1270 **WYR** have a bigger master bedroom or a bigger kitchen in your new home?

1271 **WYR** have to ride a horse or a unicycle to work every day for a week?

1272 **WYR** learn more about the stock market or real estate market?

1273 **WYR** suck 10 lemons or 10 fish heads?

1274 **WYR** turn into the Creature from the Black Lagoon every full moon or have bone like spikes down your spine?

1275 **WYR** be a terrible friend or terrible lover?

1276 **WYR** have a *Cosby Show* or *Brady Bunch* remake for TV?

1277 **WYR** be treated special or be treated fair?

1278 **WYR** have the perfect relationship or perfect job?

1279 **WYR** have Godiva or Hershey chocolate?

1280 **WYR** be the face of an alcoholic beverage or a cigarette brand?

1281 **WYR** join the cast of *Pitch Perfect* or *High School Rock*?

1282 **WYR** not say anything if you have nothing nice to say or just say what you want?

1283 **WYR** watch *Bad Santa* or *The Nightmare Before Christmas*?

1284 **WYR** have Clark Griswold or Noah Levenstein (*American Pie*) for a dad?

1285 **WYR** use Amazon Echo or Google Home?

1286 **WYR** slide down a sand dune or snowy hill?

1287 **WYR** give up your social life or give up everything else but your social life?

1288 **WYR** be needed or desired?

1289 **WYR** sing with Kelly Clarkson or Pink?

1290 **WYR** wear a onesie or overalls all day while you're out in public?

1291 **WYR** never sleep in socks or always sleep in socks?

1292 **WYR** eat your nuts honey roasted or lightly salted?

1293 **WYR** snowball fight or food fight?

1294 **WYR** get a terrible wedgie or have someone moon you?

1295 **WYR** always have your teeth feel clean or always have fresh breath?

1296 **WYR** not know your worth or always know your value?

1297 **WYR** remove Charlie Sheen or O.J. Simpson from the planet?

1298 **WYR** drink iced tea or hot tea?

1299 **WYR** use lotion or coconut oil on your skin?

1300 **WYR** lie to your doctor or lie to yourself?

1301 **WYR** eat veggie chips or banana chips?

1302 **WYR** have donuts or donut holes?

1303 **WYR** move in with your mate too soon or never move in with them and they move on?

1304 **WYR** attend a drag show or a drag race?

1305 **WYR** forget friends from your childhood or stay in contact with them?

1306 **WYR** inspire people or educate them?

1307 **WYR** have a free attorney anytime you need one or a free psychologist whenever you need to talk?

1308 **WYR** always eat food that is bitter or spicy?

1309 **WYR** give your children the ability to choose their own religion or impart your beliefs on them when they're young?

1310 **WYR** break up with someone in person or by text?

1311 **WYR** skateboard or hoverboard through your neighborhood?

1312 **WYR** have endless hiccups or laugh until you pass out?

1313 **WYR** be diagnosed with a mental disorder or physical disorder?

1314 **WYR** have a constant tingling in your hands and feet or a constant burning in your eyes?

1315 **WYR** play an adult game of *Twister* with friends or naked hide-n-seek with neighbors?

1316 **WYR** always have your flights delayed or always be seated by annoying people on a plane?

1317 **WYR** prevent all future school shootings or all future terrorist acts?

1318 **WYR** do a ride along with a police officer or hang out at a fire station?

1319 **WYR** do all your grocery shopping only online or only in store?

1320 **WYR** clone yourself or clone your favorite pet?

1321 **WYR** eat out every day for a year or cook at home every day for a year?

1322 **WYR** lie to yourself to make you feel better or face your truth and deal with the pain?

1323 **WYR** be the last person left on Earth or the only person transferred to a newly discovered planet to procreate?

1324 **WYR** have hallucinations for 24 hours or experience vertigo for 48 hours?

1325 **WYR** be the one chosen to build an ark similar to Noah to save your family from a flood or hire a person to build it but leave half your family behind?

1326 **WYR** die for a cause you believe in or die protecting strangers in a dangerous situation?

1327 **WYR** the world had giant locusts or giant crows?

1328 **WYR** pierce both eyebrows or both nostrils?

1329 **WYR** use mouthwash that tastes like vinegar or eye drops that burn like hot sauce?

1330 **WYR** have a demogorgon as a pet or the ability to change into a demogorgon?

1331 **WYR** be completely hairless all over your body or have too much hair all over your body?

1332 **WYR** send an embarrassing email to your entire family or all your co-workers?

1333 **WYR** be a cyclops or a minotaur?

1334 **WYR** eat one stick of lard (Crisco) or drink one cup of unpasteurized goat milk?

1335 **WYR** give up shopping for new things or give up grooming for an entire year?

1336 **WYR** battle rap Eminem or Drake?

1337 **WYR** change humanity's chemical makeup or physical design?

1338 **WYR** eat Cadbury or Willy Wonka candies?

1339 **WYR** get rid of celebrity award shows altogether or just get rid of some?

1340 **WYR** Matthew McConaughey or Samuel Jackson read you a bedtime story?

1341 **WYR** get rid of the "National Anthem" or "Pledge of Allegiance?"

1342 **WYR** spend your extra time doing Facebook quizzes or reading listicles?

1343 **WYR** never have another good hair day or your clothes never be on point again?

1344 **WYR** always know what you want to eat or always know what your mate is thinking?

1345 **WYR** be too picky or not picky enough?

1346 **WYR** have proof we landed on the moon or proof aliens exist?

1347 **WYR** hope for the best or prepare for the worst?

1348 **WYR** eat Rice Krispies with milk as cereal or as Rice Krispies treats?

1349 **WYR** be lost in emotion or lost in translation?

1350 **WYR** dye your hair white or gray?

1351 **WYR** lose a bet to a stranger or your best friend?

1352 **WYR** eat parsley or cilantro as a garnish?

1353 **WYR** be close with your sibling or be in competition with them?

1354 **WYR** have a funny bumper sticker or funny t-shirt?

1355 **WYR** eat string cheese or cheesecake?

1356 **WYR** jam Run DMC or Beastie Boys?

1357 **WYR** have professional portraits or take your own selfie for your profile photos?

1358 **WYR** spend more money at the Playstation store or on iTunes?

1359 **WYR** have a water view or skyline view out of your apartment?

1360 **WYR** change your name or change your personality?

1361 **WYR** flip on a trampoline or flip off a diving board?

1362 **WYR** always know what your best friend is thinking or have your own personal revelation?

1363 **WYR** live in London or Rome?

1364 **WYR** speak with an accent or never have an accent?

1365 **WYR** write commercial jingles or theme songs to TV shows?

1366 **WYR** a stranger sneeze in your face or lick your hand?

1367 **WYR** find tons of chewed gum or a dried-up booger under a table where you're eating dinner?

1368 **WYR** quit your job and become a waiter and live off tips or freelancer and live off odd jobs?

1369 **WYR** pull a tooth with a pair of pliers or brand yourself with a cattle prod?

1370 **WYR** always have boogers in your nose or food stuck in your front teeth?

1371 **WYR** kiss an iguana or a centipede?

1372 **WYR** rock your grandma's hairstyle for a week or drink a glass of water dentures have sitting in overnight?

1373 **WYR** get pooped on by a bird 3 times a day for a week or have poison ivy for a month?

1374 **WYR** give 100 dogs a bath or milk 100 dairy cows?

1375 **WYR** have more faith in God or trust people more?

1376 **WYR** drink a glass of your significant other's blood or your own blood?

1377 **WYR** take a bath in bourbon or coffee?

1378 **WYR** your job give you a longer lunch and breaks or more employee sharing benefits?

1379 **WYR** wear cologne/perfume that smells like beer or tacos?

1380 **WYR** have more time with your family or more time for yourself?

1381 **WYR** be tone deaf or colorblind?

1382 **WYR** wear dentures the rest of your life or have no fingernails?

1383 **WYR** break every promise you ever make to people or lie to everyone you love?

1384 **WYR** potty-train 10 puppies or 5 toddlers?

1385 **WYR** finish first place at an important marathon or attempt a triathlon, finish last but not give up?

1386 **WYR** your lotion contain menthol, or your shampoo contain mosquito repellant?

1387 **WYR** have a barbecue on the beach or on top of a mountain?

1388 **WYR** get married underwater or on top of a skyscraper?

1389 **WYR** only ever get to wear glasses or contact lenses?

1390 **WYR** have more people that love you or motivate you in your life?

1391 **WYR** run for mayor of your city or governor of your state?

1392 **WYR** have sex in a church or the back of a hearse?

1393 **WYR** play chicken with tractors or cars?

1394 **WYR** throw garden snakes on little old ladies who are lunching or wake up your grandparents by playing the drums next to their bed?

1395 **WYR** always be early or always be late?

1396 **WYR** mourn a death alone or with family and friends to comfort you?

1397 **WYR** read *Popular Science* or *Popular Mechanics*?

1398 **WYR** get into a spitball or pillow fight?

1399 **WYR** be exiled from society or disowned from your family?

1400 **WYR** Austin Powers or James Bond be at your service?

1401 **WYR** be eaten by Audrey from *Little Shop of Horrors* or attacked by killer tomatoes?

1402 **WYR** have a second job or one's enough?

1403 **WYR** eat dinner with your family or with your friends?

1404 **WYR** work late or get up early?

1405 **WYR** feel connected to the universe or connected to a person?

1406 **WYR** go on a road trip with Oprah or Jimmy Kimmel?

1407 **WYR** be bitten by a tiger shark or a bull shark?

1408 **WYR** visit the most beautiful beach or the most beautiful countryside in the world?

1409 **WYR** only eat Taco Bell or Subway for lunch?

1410 **WYR** drink Tang or Kool-Aid with your friends?

1411 **WYR** eat Fun Dip or Pixie Stix?

1412 **WYR** give out money or candy to the kids in your neighborhood for Halloween?

1413 **WYR** sing "Silent Night" or "Jingle Bells" when you go caroling?

1414 **WYR** create a treasure hunt or scavenger hunt as your next big outing?

1415 **WYR** carve a pumpkin or go for a hayride this upcoming autumn?

1416 **WYR** be more afraid of water or heights?

1417 **WYR** always keep it simple or rock the boat?

1418 **WYR** bring back Whitney Houston or Aaliyah?

1419 **WYR** use only tobacco or sriracha?

1420 **WYR** always have Lo Mein noodles or fried rice with your Chinese takeout?

1421 **WYR** always avoid bad dates or block online creepers from stalking you?

1422 **WYR** make celebrities get drug tested or have salary caps per movie/show?

1423 **WYR** be Nicolas Cage in *Con Air* or *Face/Off*?

1424 **WYR** be too serious or not serious enough?

1425 **WYR** be the life of the party or fight for your right to party?

1426 **WYR** live right in the heart of a big city or out in the quiet countryside?

1427 **WYR** sleep outside for a year or sleep alone for a year?

1428 **WYR** have all your debt paid off right now or be given a new car right now?

1429 **WYR** have a praying mantis or Japanese rhinoceros beetle as a pet?

1430 **WYR** attempt a career at Pro Wrestling or have the chance to take a case before the Supreme Court?

1431 **WYR** be locked inside the *Big Brother* house or *Jersey Shore* house?

1432 **WYR** be conceited or shallow?

1433 **WYR** have your own clothing line or your own skin care line?

1434 **WYR** have the chance to create a smart phone app or video game?

1435 **WYR** get hit in the face by a tennis ball or football?

1436 **WYR** spend the last year of your life partying or making a difference in the world?

1437 **WYR** wear a cap or bandana on your head every day for a year?

1438 **WYR** humble yourself and become a janitor or dishwasher?

1439 **WYR** walk around with your hands and feet dyed blue or vulgar graffiti sprayed all over your car?

1440 **WYR** eat a raw beet or raw turnip?

1441 **WYR** your teenager be addicted to taking selfies or candy and junk food?

1442 **WYR** spend a year living at a nudist colony or within the Amish community?

1443 **WYR** eat only Italian style food or authentic Mexican style food for an entire year?

1444 **WYR** wear crazy wigs every day for a month or wear your bathing suit each time you go to the grocery store for a year?

1445 **WYR** have swollen lips or swollen fingers?

1446 **WYR** have to wear sock puppets on your hands or flippers on your feet?

1447 **WYR** have short-term or long-term memory loss?

1448 **WYR** save all your pennies or throw all your pennies away?

1449 **WYR** have a stray dog lick your face or get lemon juice in a really bad cut you have?

1450 **WYR** perform CPR on a baby you don't know or your elderly grandfather (chose only one)?

1451 **WYR** make your parents or your significant other take a lie detector test?

1452 **WYR** have explosive diarrhea for a week or be constipated severely for a week?

1453 **WYR** be locked in a coffin or gym locker for an hour?

1454 **WYR** have a magic button to change every red light to green or have a car that recycles its own fuel?

1455 **WYR** have a baby pee or vomit on you?

1456 **WYR** always buy a real Christmas tree or only use a fake Christmas tree?

1457 **WYR** have a leg or breast when you eat your chicken?

1458 **WYR** have less disappointments or less problems in your life?

1459 **WYR** eat homemade potato chips or bagged potato chips?

1460 **WYR** avoid pain or avoid stress?

1461 **WYR** people keep you guessing or just be upfront?

1462 **WYR** understand what the movie *Donnie Darko* or *Looper* is about?

1463 **WYR** be an American Psycho or a Black Swan?

1464 **WYR** attend carnivals or festivals?

1465 **WYR** only ever go to Austin City Limits or Coachella?

1466 **WYR** be an ER nurse or pediatric nurse?

1467 **WYR** be stuck on *Shutter Island* or locked inside *Inception*?

1468 **WYR** be a true believer or total skeptic?

1469 **WYR** *Game of Thrones* or *True Blood* go on forever?

1470 **WYR** play mind games or pull heart strings?

1471 **WYR** do 100 jumping jacks or pushups?

1472 **WYR** be the chaperone of your kid's school dance or field trip?

1473 **WYR** be a cool or scary babysitter?

1474 **WYR** attend Dave Chappell's or Chris Rock's next standup comedy show?

1475 **WYR** be a ghost writer who is paid well or a struggling writer waiting on a break?

1476 **WYR** feel guilty or remorseful?

1477 **WYR** achieve a higher state of enlightenment or success?

1478 **WYR** have a *Cinderella* or *Pretty Woman* fantasy?

1479 **WYR** Harvey Weinstein or Kevin Spacey go to jail?

1480 **WYR** have the most high-tech security system or two ferocious guard dogs for your home?

1481 **WYR** jump in a public fountain that says, "keep out" or pull the fire alarm at a fancy hotel?

1482 **WYR** carry a torch for someone your whole life or put out the fire?

1483 **WYR** suffer from hallucinations or paranoia?

1484 **WYR** talk to dead people or be able to predict when people are going to die?

1485 **WYR** take it easy or take the lead?

1486 **WYR** read your original poem at a poetry slam or perform at a comedy open mic night?

1487 **WYR** have all your dreams analyzed and interpreted for meaning or be able to give someone nightmares?

1488 **WYR** have a famous parent or a famous significant other?

1489 **WYR** be able to see in the pitch-black dark or hear people's inner thoughts?

1490 **WYR** give all teachers a raise or employ more police officers throughout the world?

1491 **WYR** say everything on your mind or never say anything on your mind?

1492 **WYR** all your clothes fit you too big or too small?

1493 **WYR** swallow all the salt in your salt shaker or eat an entire bottle of horseradish?

1494 **WYR** never be able to use search engines again or never use smart phone apps again?

1495 **WYR** always have a black eye or bloody nose?

1496 **WYR** have free plane tickets (for just you) for life or have 3 get out of jail free cards that free you for everything except murder?

1497 **WYR** always have a runny nose or a ringing in your ear?

1498 **WYR** lose your ability to be empathetic or logical?

1499 **WYR** have connections in the CIA or Interpol?

1500 **WYR** be granted 10 wishes and keep them all or share half of your wishes with someone else?

1501 **WYR** have the power of persuasion or the gift of gab?

1502 **WYR** people not take you seriously or always be afraid of you?

1503 **WYR** always have to walk in straight line or never be able to use power tools again?

1504 **WYR** abolish people trapping for furs and animal hides or abolish preservatives in all food?

1505 **WYR** be forced to high-five everyone you make eye contact with or strike up conversations with at least 5 strangers a day?

1506 **WYR** eliminate Sprite or root beer?

1507 **WYR** the government put barcodes on your wrist or microchip you?

1508 **WYR** always make the first move or never take initiative?

1509 **WYR** see Dominic Toretto or Ricky Bobby drive?

1510 **WYR** never be able to be harmed from bullets again or have an invisible protective shield around your car to protect you from any accidents?

1511 **WYR** only be able to use the opposite hand you use now or drive only using one hand?

1512 **WYR** have your family/friends perceive your significant other as a loser or liar?

1513 **WYR** be a peace maker or an instigator?

1514 **WYR** have a snowball or water balloon fight?

1515 **WYR** lose your left leg or your right arm?

1516 **WYR** watch a feel-good movie or a motivational movie?

1517 **WYR** shake hands with Rosa Parks or Susan B. Anthony?

1518 **WYR** work with Nick Cannon or Nickelodeon?

1519 **WYR** own the world's most comfortable sheets or shoes?

1520 **WYR** use disposable razors or electric shavers?

1521 **WYR** have a clean bathtub or clean refrigerator at all times?

1522 **WYR** soak in a jacuzzi or relax in a sauna?

1523 **WYR** give up your gym membership or something else if you had to tighten your budget?

1524 **WYR** slow down time or speed up time?

1525 **WYR** give up hot dogs or hamburgers?

1526 **WYR** be given a Cartier or Montblanc pen?

1527 **WYR** have Raisinets or Whoppers at the movies?

1528 **WYR** chug orange or grape soda?

1529 **WYR** be called square or shady?

1530 **WYR** adopt the motto "life's a beach" or "life is like a box of chocolates"?

1531 **WYR** the world have more equality or more tolerance?

1532 **WYR** live your truth or spend more time figuring out your truth?

1533 **WYR** have more time to write or more time to read?

1534 **WYR** movies have less sequels or less remakes?

1535 **WYR** tip waiters based on service or always leave at least 15%?

1536 **WYR** eat a kale or seaweed salad?

1537 **WYR** build a man cave or she shed?

1538 **WYR** get rid of MTV or VH1?

1539 **WYR** have a sword fight or a fist fight?

1540 **WYR** spend all day listening to Pearl Jam or Nirvana?

1541 **WYR** always type or always write by hand?

1542 **WYR** eat lasagna or spaghetti?

1543 **WYR** live and let live or live and let die?

1544 **WYR** Shel Silverstein or Dr. Seuss?

1545 **WYR** sleep with the TV on or use a nightlight?

1546 **WYR** be lost in the worst part of town you know or break down on an abandoned highway?

1547 **WYR** lose your ability to concentrate or lose your ability to be creative?

1548 **WYR** be an excellent cook or have a significant other that is an excellent cook?

1549 **WYR** always get the last word in an argument or always get the best seat in the house?

1550 **WYR** be too trusting or too suspicious of everyone you meet?

1551 **WYR** interview an infamous serial killer or a victim of a highly publicized crime?

1552 **WYR** date someone who is very popular with tons of friends or someone who is more of a homebody with only a few friends?

1553 **WYR** plan a family reunion or your class reunion?

1554 **WYR** work harder or work smarter?

1555 **WYR** your clothes always be itchy or wrinkly?

1556 **WYR** sit all day or stand all day at your job?

1557 **WYR** be under 5 feet tall or over 7 feet tall?

1558 **WYR** live with your parents for the next 10 years or live in a halfway house for the next 5 years?

1559 **WYR** have unwavering willpower or a high IQ score?

1560 **WYR** throw a surprise party or have someone throw you a surprise party?

1561 **WYR** get revenge or forgive the last person who upset you?

1562 **WYR** eat human flesh to survive or starve to death?

1563 **WYR** be someone's first love or someone's last love?

1564 **WYR** work the graveyard shift alone and be off on weekends or work every weekend but have help?

1565 **WYR** get a shoulder massage or a foot massage?

1566 **WYR** always have a clean bathroom or clean kitchen in your home?

1567 **WYR** be a good listener or a good negotiator?

1568 **WYR** spend the day relaxing in the park or shopping at the mall?

1569 **WYR** read hardcover books or read books in digital format?

1570 **WYR** play computer games or games on a console?

1571 **WYR** marry someone who challenges you or one who is overly supportive?

1572 **WYR** date someone who gets along with your family or who gets along with your friends (can't be both)?

1573 **WYR** lick your significant other's armpit or a stranger's ear?

1574 **WYR** be the smartest person you know or the most popular in your circle of friends?

1575 **WYR** eat a bar of soap or drink an entire bottle of laxative?

1576 **WYR** watch your enemy drown to death or bleed to death?

bleed to death

1577 **WYR** belong to the crew of *Mission Impossible* or *Ocean's Eleven*?

1578 **WYR** play only Parker Brothers or Hasbro games?

1579 **WYR** have a secret lover or secret admirer?

1580 **WYR** tell ghost stories or urban legends?

1581 **WYR** end bull fighting or dog fighting?

1582 **WYR** life always be fair or continue with life as we know it?

1583 **WYR** never be able to change your mind or never be able to make up your mind?

1584 **WYR** always have your car exterior clean but the interior be dirty or vice versa?

1585 **WYR** kiss face on a park bench or in a parked car?

1586 **WYR** get more exercise or get more outdoor activities?

get more exercise

1587 **WYR** eat out more or eat at home more?

eat at home more

1588 **WYR** things become more compact or more oversized?

1589 **WYR** live through *Perfect Storm* or *Armageddon*?

1590 **WYR** purchase a more expensive car or a more expensive home?

expensive House

1591 **WYR** appreciate the people in your life more or forgive yourself more?

1592 **WYR** tell people you love them more often or find more creative outlets in your life?

1593 **WYR** Beyoncé stay married to Jay-Z or become a single lady again?

1594 **WYR** your environment have less bugs or less snakes?

less snakes

1595 **WYR** avoid or embrace your current reality?

1596 **WYR** be the captain of a cruise ship or yacht?

1597 **WYR** have an endless supply of sunflower seeds or peanuts?

1598 **WYR** have muffins or scones at your next tea party?

1599 **WYR** people commit less crimes or pollute the environment less?

less crimes

1600 **WYR** fish off a pier or off a boat?

fish off a pier

1601 **WYR** dive into the deep end of a pool or float in the shallows?

1602 **WYR** sing or dance in public?

1603 **WYR** be stranded at a bus stop or airport?

1604 **WYR** perform country line dancing or the Cha Cha Slide?

1605 **WYR** your body have the perfect measurements or have the perfect IQ?

Perfect IQ

1606 WYR build an epic sandcastle or decent treehouse?

1607 WYR be all knowing or have tons of materialistic things?

1608 WYR take a year off with pay or have a year added to your life?

1609 WYR be the best player on a losing team or the worst player on a winning team?

1610 WYR be caught in a human size spiderweb waiting on a giant spider or stuck in a giant-sized mouse trap waiting on a giant rat?

1611 WYR get shot by a nail gun or a staple gun?

1612 WYR harbor a fugitive you believe is innocent or turn a family member in who committed a bad crime?

1613 WYR be a bounty hunter or a blue-collar worker?

1614 WYR be with someone who lied about their past or is currently lying to you about their job?

1615 WYR go on a group date or double date?
 double date

1616 WYR save yourself or your significant other from imminent danger?

1617 WYR cuddle under the stars or on the couch?
 cuddle under the stars

1618 WYR be woken up in the morning by a kiss or the smell of fresh brewed coffee?
 by a kiss

1619 WYR always have to use a public toilet or only shower at your gym (nowhere else)?

1620 WYR have access to your friend's medical records or get a copy of your employee file?

1621 **WYR** live in your car for a month or live at a friend's house for a year?

1622 **WYR** always be filled with hunger or hatred?

1623 **WYR** fall in love too easily or never fall in love?

1624 **WYR** always have a clean house or always have a working car?

clean house

1625 **WYR** slip and fall in the middle of a restaurant full of people or in the middle of a department store?

1626 **WYR** get into a food fight with co-workers at work or paintball gun fight in your living room with family?

1627 **WYR** be forced to shower in stilettos or wearing a life preserver?

1628 **WYR** have survivor's remorse or a lack of conscience?

1629 **WYR** have a best friend who is a genius or a billionaire?

a billionaire

1630 **WYR** be a survivor or a walker in *The Walking Dead*?

1631 **WYR** dress like a pimp or a gangster from the 20s?

1632 **WYR** Rudolph the Red-Nosed Reindeer or the Easter Bunny be real?

1633 **WYR** everyone believe everything you say or do everything you say?

believe everything i say

1634 **WYR** sweat too much or cough too much?

1635 **WYR** be too needy or too greedy?

too needy

1636 **WYR** rock Sketchers or New Balance?

1637 **WYR** eat peanut butter and jelly or grilled cheese sandwiches every day?

1638 **WYR** make a mockery out of something or make a mountain out of a molehill?

1639 **WYR** buy a Sony or Samsung flat screen TV?

1640 **WYR** allow your kids to watch rated R movies or never watch them?

1641 **WYR** always have high expectations or never expect too much?

1642 **WYR** have the hookup from your waiter or cable guy?

Waiter

1643 **WYR** drink from a water hose at your home or a public water fountain?

1644 **WYR** be a reporter for pop culture or politics?

1645 **WYR** read *GQ* or *Glamour*?

1646 **WYR** wear an expensive watch that doesn't tell time or a cheap watch that functions great?

1647 **WYR** do #2 in a public restroom or hold it until you get home?

1648 **WYR** watch *Grease* or *Grease 2*?

1649 **WYR** eat only Doritos or Funyuns for life?

1650 **WYR** things get easier for you or get out of your comfort zone?

get out of your comfort zone

1651 **WYR** play the cards you're dealt or forfeit the game?

1652 **WYR** take an uncharted backroad or go the familiar route?

uncharted backroad

1653 **WYR** try not to offend anyone or do what's best for you?

1654 **WYR** steal Dracula's cape or Batman's cape?

1655 **WYR** watch the original *Karate Kid* or the remake?

1656 **WYR** have French toast or pancakes for breakfast in bed?

french toast

1657 **WYR** attend a private concert where Ed Sheeran or Charlie Puth is performing?

1658 **WYR** be friends with Justin Timberlake or Justin Bieber?

Justin

1659 **WYR** listen to an acoustic or electric guitar?

electric

1660 **WYR** have your own camel or ostrich?

1661 **WYR** be a beach bum or a vagabond?

beach bum

1662 **WYR** hear a stir of echoes or see mysterious shadows?

1663 **WYR** always know what's going on or sometimes be clueless?

1664 **WYR** play the keyboard or piano?

Piano

1665 **WYR** the world have more amusement parks or zoos?

1666 **WYR** get a road rash from falling or a really bad sunburn?

1667 **WYR** suffer from amnesia or seizures?

1668 **WYR** kiss on the cheek or French kiss on the first date?

1669 **WYR** see your neighbor or your significant other's best friend naked?

1670 **WYR** be good with kids or adults with disabilities?

1671 **WYR** participate in a search party for a missing person or pass out flyers for your BFF's missing dog?

1672 **WYR** the toilet clog every time you flush it or blow a fuse each time you use the microwave?

1673 **WYR** have telepathy or telekinesis?

1674 **WYR** never pay off your debt or never pay back a friend who lent you money?

1675 **WYR** shut down tobacco companies or shut down the companies that cause the most pollution?

1676 **WYR** make your diary public or leak every secret anyone has ever told you online?

1677 **WYR** your head be too big or too small for your body?

1678 **WYR** face nuclear winter or alien invasion?

1679 **WYR** volunteer at the YMCA or SPCA?

1680 **WYR** live in a haunted house or live near a haunted cemetery?

1681 **WYR** experience a miracle or witness a shooting star?

1682 **WYR** join a bowling league or fantasy football league?

1683 **WYR** go bowling with a coconut or watermelon as your bowling ball?

1684 **WYR** have a joint bank account with a friend that has a spending problem or an enemy who is frugal?

1685 **WYR** only be able to have twins if you have kids or just not have kids at all?

1686 **WYR** be a new character on the TV show *Stranger Things* or *The Walking Dead*?

1687 **WYR** live the next 5 years of your life in the wilderness of Alaska or the desert of Abu Dhabi?

1688 **WYR** snort wasabi or get a jalapeno seed stuck in your eye?

1689 **WYR** have gas or anxiety on your wedding day?

1690 **WYR** only be able to eat at your favorite restaurant or eat everywhere but your favorite restaurant again?

1691 **WYR** change history or shape the future?

1692 **WYR** spend money travelling or a fancy car?

1693 **WYR** have an MTV Award or Nickelodeon Kid's Choice Award?

1694 **WYR** live a more luxurious or casual lifestyle?

1695 **WYR** have a real estate license or private detective license?

1696 **WYR** blow all your money at casinos or on lottery tickets?

1697 **WYR** eat a salad with a worm or fake fingernail in it?

1698 **WYR** have your eyes always water or your head always itch?

1699 **WYR** be a godparent or a foster parent?

1700 **WYR** walk across a dirty parking lot or a pasture full of livestock barefoot?

1701 **WYR** have free groceries for a year or all bills paid for 6 months?

1702 **WYR** Carrie Bradshaw pick out your wardrobe or Stanford Blatch play matchmaker for you?

1703 **WYR** have your entire home remodelled at no charge or all the free plastic surgery you want?

1704 **WYR** read only *Buzzfeed's* or *Huffington Post's* blog?

1705 **WYR** make movies always have a happy ending or always leave you wondering?

1706 **WYR** cover all your food in gravy or cheese?

1707 **WYR** be in an online group for *World of Warcraft* or *Black Ops*?

1708 **WYR** face Darth Vader or Darth Maul in a lightsaber fight?

1709 **WYR** find all your missing socks or never lose your favorite pen again?

1710 **WYR** eat what you find under your sofa cushions or between the seats of your car?

1711 **WYR** eat a plate of tofu or bowl of Vegemite?

1712 **WYR** burn incense that smells like gasoline or cheap perfume?

1713 **WYR** be called a nickname you hate or an insulting cartoon character?

1714 **WYR** eat out of a dumpster behind a restaurant or eat out of your neighbor's trash can?

1715 **WYR** go through Navy Seal or Marine Corps training?

1716 **WYR** be a one hit wonder in music or a TV show that gets cancelled after 3 episodes?

1717 **WYR** attend an authentic Hawaiian luau or Native American pow wow?

1718 **WYR** live in Canada or Mexico for a year?

1719 **WYR** bring back something from your childhood or see someone from childhood you miss?

1720 **WYR** discover a hidden talent you didn't know you had or help someone discover their talents?

1721 **WYR** have a comfy pillow and blanket or delicious food and drink on a long flight?

1722 **WYR** only be allowed to wear one clothing designer or one shoe designer?

1723 **WYR** your voice sound like Elmo or Kermit the Frog?

1724 **WYR** trust your pet to a kennel or leave them with someone you trust when you travel without them?

1725 **WYR** always eat black beans or red beans?

1726 **WYR** have kombucha or kimchi daily?

1727 **WYR** have Korean BBQ or Thai food?

1728 **WYR** be a cab driver in New York or bike messenger in Chicago?

1729 **WYR** make snow angels or a snow man in the winter?

1730 **WYR** be buried alive or painfully poisoned?

1731 **WYR** always have closure or some things are better left unknown?

1732 **WYR** eat caramel coated apples or chocolate dipper strawberries?

1733 **WYR** have a son or a daughter?

1734 **WYR** have a better attitude or better character?

1735 **WYR** spend the day with Bob Marley or Martin Luther King Jr.?

1736 **WYR** have good friends or good books?

1737 **WYR** have better judgement or stronger intuition?

1738 **WYR** see someone's potential or know how they'll make your life better?

1739 **WYR** have sorbet or ice cream sandwiches?

1740 **WYR** have more music in your life or less noise?

1741 **WYR** never say please or never say thank you?

1742 **WYR** use Gmail or Yahoo?

1743 **WYR** be an undercover snitch or a bully?

1744 **WYR** stand up for yourself or others more?

1745 **WYR** have a steak dinner or a seafood platter?

1746 **WYR** be a hyena or vulture?

1747 **WYR** inherit it all or work for everything you have?

1748 **WYR** get a hand out or a leg up?

1749 **WYR** see other's point of view or keep your own perspective intact?

1750 **WYR** visit the Philippines or Indonesia?

1751 **WYR** your mom date your best friend or the dad of your significant other?

1752 **WYR** shop Overstock.com or Wayfair.com?

1753 **WYR** be addicted to Pinterest or Twitter?

1754 **WYR** only eat French fries or tater tots?

1755 **WYR** have an awesome collection of something or not waste time collecting things?

1756 **WYR** wear your jeans inside out or your shoes on the wrong feet for a day?

1757 **WYR** play miniature golf dressed as a sumo wrestler or put socks on your hands and have them talk to everyone you see?

1758 **WYR** have a bucket stuck on your head or your hand get stuck in a pickle jar?

1759 **WYR** be covered in fleas or ants?

1760 **WYR** risk a meteor hitting earth or an outbreak similar to the black plague spreading across country?

1761 **WYR** a bug flies up your nose or down your throat?

1762 **WYR** wear a Christmas sweater in July or a Halloween costume at a New Year's Eve party?

1763 **WYR** have a sports car with or without a convertible top?

1764 **WYR** ride the X-Scream or Insanity at the Stratosphere in Las Vegas?

1765 **WYR** enter a contest at a county fair or compete in one of the games at a carnival?

1766 **WYR** visit Graceland or Neverland Ranch?

1767 **WYR** play the kazoo or finger cymbals?

1768 **WYR** not be able to bend your arms or legs?

1769 **WYR** have 10-inch-long fingernails or toenails?

1770 **WYR** have chewing gum stuck in your hair or up your nose?

1771 **WYR** never be able to use a calculator again or never use a ruler/tape measure ever again?

1772 **WYR** win the lottery and receive $10,000 a week for the next 50 years or get one lump sum of $2 million right now?

1773 **WYR** have a more beautiful face or more fit body than what you have now?

1774 **WYR** have less stress in your life or less responsibilities?

1775 **WYR** be part of chart topping band and share the accolades or be a solo artist waiting on your big break?

1776 **WYR** meet Confucius or Isaac Newton?

1777 **WYR** be more technologically inclined or better with people?

1778 **WYR** waste time or waste money?

1779 **WYR** never have to shave again or never have to style your hair again?

1780 **WYR** die by drowning or by fire?

1781 **WYR** be handcuffed all day to your crush or someone who makes you laugh?

1782 **WYR** drive backwards down a busy street or ride a bike down a huge hill blindfolded?

1783 **WYR** use a pogo stick on an icy lake or ride a wild horse without a saddle?

1784 **WYR** have the winning hand at a major poker tournament or the keys to happiness?

1785 **WYR** have your own minion or your own gremlin?

1786 **WYR** have fangs and claws or wings?

1787 **WYR** work at a zoo with your favorite animal or work as a cartoon character at an amusement park?

1788 **WYR** live on bread and water for a month or eat anything you want but you have to add a cooked insect to one of your meals each day?

1789 **WYR** be a shape shifter or be able to manipulate water?

1790 **WYR** have the ability to decode and cypher any encryption or be an elite code writer?

1791 **WYR** surround yourself with people who party all the time or pursue their dreams?

1792 **WYR** be in business with *The Godfather* or *Scarface*?

1793 **WYR** always make a bad first impression or never leave a lasting impression?

1794 **WYR** be enemies with The Punisher or Robin Hood?

1795 **WYR** have insomnia or amnesia for a month?

1796 **WYR** give up donuts or pizza forever?

1797 **WYR** kill in self-defense or kill in revenge?

1798 **WYR** have rice thrown or doves released at your wedding?

1799 **WYR** become a famous architect or an important astronomer?

1800 **WYR** have a cooking showdown against Bobby Flay or Curtis Stone?

1801 **WYR** be a local news anchor or a national weather forecaster?

1802 **WYR** soak in the Dead Sea or the mineral rich mud baths at Calistoga Springs?

1803 **WYR** kiss the Blarney Stone in Ireland or visit Balzac's house in Paris?

1804 **WYR** improvise and use a trash can or bucket as a toilet?

1805 **WYR** write reviews for Yelp or Google?

1806 **WYR** be the spokesperson for a hemorrhoid cream or face of an adult diaper brand?

1807 **WYR** own a jet ski or snow ski?

1808 **WYR** drink a glass full of raw eggs or eat 10 cans of Spam?

1809 **WYR** have more passion or more trust in your relationship?

1810 **WYR** perform singing telegrams or be a wedding singer?

1811 **WYR** play 20 questions or truth or dare with a stranger?

1812 **WYR** donate blood that goes to whoever needs it or store your own blood at a bank for yourself, family and friends when they need it?

1813 **WYR** work the roulette wheel or blackjack table in Las Vegas?

1814 **WYR** attend career day at an elementary school and talk about your job or speak to teenagers about the dangers of drugs?

1815 **WYR** play on a roller derby or ice hockey team?

1816 **WYR** fly on Air Force One or ride first class on the best airline in the world?

1817 **WYR** rappel down the Statue of Liberty or Eiffel Tower?

1818 **WYR** get stuck in the cargo hold of an airplane or restroom the entire flight?

1819 **WYR** visit the largest mall in the world or The Coliseum?

1820 **WYR** learn tap from Savion Glover or learn how to croon from Michael Bublé?

1821 **WYR** get a paper cut on your tongue or your eyelid?

1822 **WYR** have a self-cleaning toilet or car?

1823 **WYR** bring back the TV show *Seinfeld* or *Friends*?

1824 **WYR** own a coffee shop or auto repair garage?

1825 **WYR** burn bridges or keep your enemies close?

1826 **WYR** write fake stories for a trashy tabloid or product test and write reviews for a consumer magazine?

1827 **WYR** pull a flash mob in a movie theater or in the middle of a restaurant?

1828 **WYR** settle for a person you like a little so you're not alone or hold out for "the one" and possibly be alone the rest of your life?

1829 **WYR** share your wealth with your kids or let them make their own money?

1830 **WYR** think outside the box or color outside the lines of life?

1831 **WYR** be called weird or rude?

1832 **WYR** Camelot or Sleepy Hollow be a real place today?

1833 **WYR** visit the Munster Museum in Waxahachie Texas or spend the night at the real Brady Bunch house in North Hollywood?

1834 **WYR** be raised by a pack of wolves or a tribe of gorillas?

1835 **WYR** praying be allowed back in schools for those who want to participate or keep it out altogether?

1836 **WYR** driving or voting age be moved to 21 years of age?

1837 **WYR** have an outbreak of bedbugs or fleas in your home?

1838 **WYR** go through life feeling guilty or with a chip on your shoulder?

1839 **WYR** eat 100 raw oysters or gourmet prepared cow tongue?

1840 **WYR** have the ability to change into another animal or assume another person's identity?

1841 **WYR** find Waldo or explore with Dora?

1842 **WYR** play with Legos or tinker toys right now?

1843 **WYR** have a driving license that never expires or tires that never go flat?

1844 **WYR** have double vision or suffer from blackouts?

1845 **WYR** be allergic to people or allergic to everything but people?

1846 **WYR** have a premonition or omen?

1847 **WYR** get recruited by *The Lost Boys* or *The Outsiders*?

1848 **WYR** be a hippie or hipster?

1849 **WYR** eat Lemonheads or listen to Lemonheads?

1850 **WYR** have a Drumstick or Klondike bar?

1851 **WYR** have strawberry shortcake or crème brûlée for dessert?

1852 **WYR** play football in the park or frisbee at the beach?

1853 **WYR** throw confetti or glitter?

1854 **WYR** shine bright like a diamond or wear the diamonds?

1855 **WYR** be in *Blade* or *Underworld*?

1856 **WYR** do a skit with Jordan Peele or Keegan-Michael Key?

1857 **WYR** bring back *All That* or *In Living Color*?

1858 **WYR** be the life of the party or a good conversationalist?

1859 **WYR** have animal crackers or graham crackers?

1860 **WYR** prove your critics wrong or silence your haters?

1861 **WYR** your computer or smartphone never crash again?

1862 **WYR** follow advice from your parents or the good book?

1863 **WYR** have Charlie Brown or Snoopy as a pal?

1864 **WYR** eat snow cones or popsicles?

1865 **WYR** get back wasted time or get back wasted energy?

1866 **WYR** make the world have one currency or one language?

1867 **WYR** never pay taxes or never pay tuition again?

1868 **WYR** have a shingles outbreak or heat stroke?

1869 **WYR** apply the *48 Laws of Power* or *The Art of War* principles to your life?

1870 **WYR** have an endless hangover or endless cough?

1871 **WYR** cheer other people up or always have someone around to cheer you up?

1872 **WYR** have spearmint or peppermint gum?

1873 **WYR** smoke a pipe or chew tobacco?

1874 **WYR** have a granny smith or red delicious apple a day?

1875 **WYR** drink castor oil or baking soda and water?

1876 **WYR** be trapped in a bizarre love triangle or be the focus of a stalker?

1877 **WYR** have horrible body odor that deodorant didn't help or severe halitosis?

1878 **WYR** figure out the meaning of life or figure out your life's purpose?

1879 **WYR** buy fake accessories (like purses and watches) if no one could tell or not wear any accessories until you can afford to buy the real ones?

1880 **WYR** make a tiny home out of a school bus or a shipping container?

1881 **WYR** have a TV sitcom or movie be made about your life?

1882 **WYR** eat the most expensive dessert or drink the most expensive champagne in the world?

1883 **WYR** interview Lois Lane or Alfred J. Pennyworth and try to pry secrets about your favorite superhero?

1884 **WYR** see a remake of *Mary Poppins* or *The Sound of Music*?

1885 **WYR** get rid of the TV show *The Kardashian's* or *Catfish*?

1886 **WYR** only be allowed to shop at Ikea or Walmart for your household décor and furniture?

1887 **WYR** go on *The Tonight Show Starring Jimmy Fallon* or *The Late Late Show with James Corden*?

1888 **WYR** have Adele or John Legend sing at your wedding?

1889 **WYR** have a highlight reel of your life so far played for your parents or your significant other?

1890 **WYR** be a chief of police or chief of the fire department?

1891 **WYR** get drunk and do something stupid or something you'll regret?

1892 **WYR** be a defendant in civil or criminal court?

1893 **WYR** have back spasms or a slipped disc in your back?

1894 **WYR** lose control or lose your faith?

1895 **WYR** put all your eggs in one basket or count your chickens before they hatch?

1896 **WYR** have an herb garden or vegetable garden?

1897 **WYR** children play sports or be more academic?

1898 **WYR** be handcuffed or zip tied?

1899 **WYR** have someone rock your world or knock your socks off?

1900 **WYR** confide in your parents or best friend?

1901 **WYR** see the end of Earth or the birth of a new civilization?

1902 **WYR** be told you look older or younger than you are?

1903 **WYR** get licked in the face by a dog or a toddler?

1904 **WYR** find a hidden tunnel or hidden room in your house?

1905 **WYR** play tug of war or flag football at your next family reunion?

1906 **WYR** read gospel hymn books or movie soundtrack lyrics?

1907 **WYR** exaggerate or under estimate?

1908 **WYR** take a leap of faith or wish upon a star?

1909 **WYR** have Dumbledore's or Gandalf's power?

1910 **WYR** work at the grocery store or a fast food restaurant the rest of your life?

1911 **WYR** have Reese Witherspoon's character Tracy Flick be your best friend or Madeline McKenzie be your mom?

1912 **WYR** watch a video compilation of your life's greatest victories or stupidest moments?

1913 **WYR** have pink eyes or purple eyebrows?

1914 **WYR** have maple syrup or honey?

1915 **WYR** graduate college with honors and no new friends or barely graduate but have tons of new friends?

1916 **WYR** have biscuits or toast with breakfast?

1917 **WYR** be a know-it-all or a smartass?

1918 **WYR** have an unlimited new movie subscription or new video game subscription?

1919 **WYR** listen to Michael Bublé or Frank Sinatra?

1920 **WYR** have a long-lost sibling and meet them or prefer not to know?

1921 **WYR** know all the skeletons in your dad's or mom's closet?

1922 **WYR** be a school bus driver or principal for a day?

1923 **WYR** be able to make it rain or snow?

1924 **WYR** live large or love long?

1925 **WYR** your doctor be the same sex as you or opposite sex?

1926 **WYR** have a hall pass to cheat on your mate or be given amnesty for a previous indiscretion?

1927 **WYR** lose the ability to get road rage or depressed?

1928 **WYR** pee in the swimming pool or get out and pee?

1929 **WYR** make fun of other people or make fun of yourself?

1930 **WYR** seek advice or ask for help?

1931 **WYR** meet every member of your family still living or only know more about members of your family that impacted history who are deceased?

1932 **WYR** wipe ants off your food at a picnic or dust mold off your bread?

1933 **WYR** McDonald's or Burger King go out of business?

1934 **WYR** invest in people going places or new technology stocks?

1935 **WYR** be humble and kind or boisterous and rude?

1936 **WYR** your spouse be driven and hardworking or totally faithful (they can't be both)?

1937 **WYR** live right next door to your parents or 1,000 miles away?

1938 **WYR** have a mentor or figure things out on your own?

1939 **WYR** log roll yourself down a hill or leap frog over fire hydrants for an entire day?

1940 **WYR** focus on staying in shape or furthering your career (you can't do both)?

1941 **WYR** get rid of mosquitos or moths?

1942 **WYR** rent a Hummer or Porsche Cayenne limo for your birthday bash?

1943 **WYR** own a vacation home in the mountains or at the beach?

1944 **WYR** get rid of all dollar stores or all fast food chains?

1945 **WYR** study for your real estate license or for the Bar examination to practice law?

1946 **WYR** have 24 hours of playtime life on *Candy Crush Saga* or original *Flappy Birds*?

1947 **WYR** drink a gallon of Ovaltine or Gatorade?

1948 **WYR** attend the funeral of your best friend or the person you're dating, if the funerals are at the same time?

1949 **WYR** earn minimum wage at a job you really love or volunteer somewhere you make a difference but is hard work?

1950 **WYR** invest in a race horse or peer-to-peer lending?

1951 **WYR** get rid of hiccups or cellulite forever?

1952 **WYR** be a silent partner in your parent's business or your significant other's business?

1953 **WYR** be an optimist or realist?

1954 **WYR** help out on GoFundMe or Kickstarter?

1955 **WYR** live in a home with green carpet and red walls but good shape or a dilapidated home that needs repairs (you can't change anything)?

1956 **WYR** toilet paper your parents' house or your in-laws' house?

1957 **WYR** know why the chicken crossed the road or what the fox says?

1958 **WYR** run from a pack of dogs holding steaks or run from one bear while covered in honey?

1959 **WYR** wear mops on your feet or sponges on your hands?

1960 **WYR** howl every night at the stroke of midnight or crow like a rooster each morning when the sun rises?

1961 **WYR** learn how to play the harp or take up rock polishing?

1962 **WYR** ride a mechanical bull or a real bull?

1963 **WYR** put your overweight child on a diet or have them do more outdoor activities?

1964 **WYR** never be allowed to use toilet paper or soap again?

1965 **WYR** a chimpanzee gives you a massage or clip your toe nails?

1966 **WYR** know your role or break the mold?

1967 **WYR** never have competition or always compete against the best?

1968 **WYR** give mouth-to-mouth resuscitation to a snake or raccoon?

1969 **WYR** ride on your favorite band's tour bus for a month or become the personal assistant to your favorite celebrity?

1970 **WYR** have more ah-ha moments or more butterfly in the stomach moments?

1971 **WYR** your house smell like vinegar or ammonia?

1972 **WYR** sabotage someone you hate or someone who has something you want but you like them?

1973 **WYR** have extra wide feet or super narrow feet?

1974 **WYR** climb trees like a monkey or run as fast as a cheetah?

1975 **WYR** eat chicken hearts or cow liver?

1976 **WYR** be an outcast with integrity or part of a clique with no morals?

1977 **WYR** take the violence out of all music or allow freedom of creativity no matter how violent?

1978 **WYR** have goat milk or buttermilk on your breakfast cereal?

1979 **WYR** be obese or anorexic?

1980 **WYR** be a Teenage Mutant Ninja Turtle or Thundercat?

1981 **WYR** have Dr. Jekyll or Dr. Frank-N-Furter experiment on you?

1982 **WYR** be Scorpion or Sub-Zero from *Mortal Kombat*?

1983 **WYR** have carpet or no carpet in your next home?

1984 **WYR** run an obstacle course or ride in a chariot race?

1985 **WYR** have more people or more things in your life?

1986 **WYR** have VIP or executive status?

1987 **WYR** your mom text you something embarrassing or your ex text you something that makes you furious?

1988 **WYR** change the present or future?

1989 **WYR** use your shirt or your friend's shirt if you needed to blow your nose and had nothing else?

1990 **WYR** have the ability to hibernate like a bear or chew through things like a beaver?

1991 **WYR** lower your expectations or raise your standards?

1992 **WYR** feel motion sickness or physical fatigue?

1993 **WYR** be a competitive champion or a champion for the human race?

1994 **WYR** eliminate paper products or eliminate emissions to save the environment?

1995 **WYR** have more grace or be shown more mercy?

1996 **WYR** wear a lit birthday cake or bird's nest with eggs on your head?

1997 **WYR** wake up every morning and think you're a different person or wake up every day in a strange location?

1998 **WYR** be a backup dancer for Jennifer Lopez or backup singer for Bruno Mars?

1999 **WYR** have someone in your life that's a burden or you be a burden to someone else?

2000 **WYR** brew your own beer or moonshine?

2001 **WYR** have an extra set of eyebrows on your forehead or a very hairy unibrow (no trimming!)?

2002 **WYR** drink out of your pet's water dish or a glass of ocean water?

2003 **WYR** mow/cut your grass with scissors or a machete?

2004 **WYR** eat a bowl of spoiled caviar or 2 spoonsful of tadpoles?

2005 **WYR** have 3 hours less or 3 hours more of sunlight each day?

2006 **WYR** be stuck upside down on an inversion table for an hour or have a barbell stuck on your chest for 10 minutes?

2007 **WYR** have a *Night at the Museum* or *Romancing the Stone* adventure?

2008 **WYR** serve food or alcohol at your wedding reception (you can't serve both)?

2009 **WYR** have a mounted moose head or a bear head as the centrepiece of your living room?

2010 **WYR** have to make your own homemade butter or never eat butter or margarine again?

2011 **WYR** eat a cheesecake where the main ingredient is flowers or some healthy green algae?

2012 **WYR** give up on your dreams to take care of a sick loved one or follow your dreams and risk that person dying without you by their side?

2013 **WYR** spend a week in the Paleolithic time period or a week in an unspecified future precognitive time period?

2014 **WYR** get rid of pop tarts or waffles?

2015 **WYR** send your child to a private school or a charter school?

2016 **WYR** a professional league for Lacrosse or Rugby get developed on the scale of the NFL?

2017 **WYR** your glasses have built in cleaning fluid with wiper blades or automatic defrosters?

2018 **WYR** walk around with a ball and chain on your leg or wear a sympathy belly for a week?

2019 **WYR** get lifestyle advice from Gwyneth Paltrow or Martha Stewart?

2020 **WYR** own and operate a food truck or petting zoo?

2021 **WYR** get rid of the iron and ironing board or feather dusters?

2022 **WYR** have a fish tank or sound machine next to your bed?

2023 **WYR** have Ozzie Osbourne or Metallica perform at your next birthday party?

2024 **WYR** share our planet with trolls or pikachus?

2025 **WYR** your life looks like the plot from *Sausage Party* or *Ratatouille*?

2026 **WYR** change human nature or society's standards?

2027 **WYR** be irreplaceable or irresistible?

2028 **WYR** try roast rattlesnake or sautéed fish heads?

2029 **WYR** know others' current intentions or know their full intention?

2030 **WYR** your favorite TV show that was cancelled get a reboot or your favorite movie get a sequel?

2031 **WYR** live a healthy life or purposeful life?

2032 **WYR** waste your potential or waste an opportunity?

2033 **WYR** eat fruit roll-ups or gummy bears?

2034 **WYR** know the truth of how you were conceived or have the biggest lie someone told you revealed?

2035 **WYR** subscribe to the motto "the more the merrier" or "three's a crowd"?

2036 **WYR** see your future self or revisit your child self?

2037 **WYR** learn more about the universe or human psyche?

2038 **WYR** history or math be obsolete?

2039 **WYR** happiness or hope be sold in vending machines?

2040 **WYR** have more intelligent or more kind people on Earth?

2041 **WYR** design a new car or create a new safety invention?

2042 **WYR** see more celebrity gossip or less celebrity gossip?

2043 **WYR** society be more advanced or less dependent on "things?"

2044 **WYR** have cherry or apple pie?

2045 **WYR** never compromise or be open to compromise?

2046 **WYR** a car run over your foot or get kicked by a donkey?

2047 **WYR** have friends with the same ideals or beliefs?

2048 **WYR** have warts on your fingers or cysts on your eyelids?

2049 **WYR** be a great storyteller or convincing liar?

2050 **WYR** donate your hair to make wigs for cancer patients for free or sell it for hair extensions and make money?

2051 **WYR** date an atheist or racist?

2052 **WYR** your skin feels slimy or bumpy?

2053 **WYR** gain insight or gain ground in your life?

2054 **WYR** always be given the benefit of the doubt or always give others the benefit of the doubt?

2055 **WYR** broaden your horizon or broaden your audience?

2056 **WYR** own 10 baby goats or a bonsai tree farm?

2057 **WYR** experience purple rain or chocolate rain?

2058 **WYR** write children's books or instruction manuals?

2059 **WYR** pick Nancy Drew or Veronica Mars when it comes to solving a mysterious crime?

2060 **WYR** play Sudoku or *NY Times* crossword puzzles all day?

2061 **WYR** have to sing all your words like the name game each time you speak or write everything in Leet speak (aka Hacker English)?

2062 **WYR** be the detectives from *The X-Files* or *Law & Order: SVU?*

2063 **WYR** drive a creepy ice cream truck or the Oscar Meyer Weiner mobile everywhere you go?

2064 **WYR** have to bedazzle all your jeans or sew decals on all your shirts?

2065 **WYR** drink food coloring straight from the bottle or eat candle wax as it's melting?

2066 **WYR** always be in a hurry or never have a sense of urgency?

2067 **WYR** have the world's largest submarine sandwich or the world's largest pizza delivered to your home?

2068 **WYR** the night stars be your guide or follow an actual compass?

2069 **WYR** your cellphone break or tooth crack while you're driving?

2070 **WYR** be more modern or more traditional?

2071 **WYR** actually see a phoenix rising or the transformation process of a werewolf?

2072 **WYR** get rid of high interest rates on any loan/credit or ban late payment penalties on everything?

2073 **WYR** shoot all your friends with a super soaker filled with squid ink or smelly clam juice?

2074 **WYR** only be allowed to drink coconut water or cactus juice?

2075 **WYR** drive your friends around on a Zamboni or John Deer tractor?

2076 **WYR** find a land of giants or a land of people small as mice?

2077 **WYR** have the Hulk or the Thing help you fight your battles?

2078 **WYR** have Wonder Woman or Erin Brockovich as your mother?

2079 **WYR** almost get hit by lightning or a car while walking?

2080 **WYR** not be prepared for an approaching storm or not have your affairs in order when you die?

2081 **WYR** see a hip-hop rap concert with your grandmother or mother-in-law?

2082 **WYR** travel the world alone or with someone?

2083 **WYR** follow the Yellow Brick Road or follow The White Rabbit?

2084 **WYR** relive one of your best days all over again or redo one of your worst days ever?

2085 **WYR** lose your ability to read or lose your ability to write?

2086 **WYR** it taste like onions or pickles each time you burp?

2087 **WYR** hear gossip about a co-worker or family member?

2088 **WYR** be locked overnight in a department store or amusement park?

2089 **WYR** always hear a clock ticking or church bells in your ear?

2090 **WYR** marry for money or love?

2091 **WYR** face a fork in the road or be forced to pick between 3 doors?

2092 **WYR** never get to buy another lottery or scratch-off ticket again or never go to the gym again?

2093 **WYR** have friends more like you or opposite of you?

2094 **WYR** visit the Netherworld from *Beetlejuice* or sunken place from *Get Out*?

2095 **WYR** burp bubbles or fart green fumes?

2096 **WYR** spray can cheese or can whip cream down your throat?

2097 **WYR** eat a jar of baby food or kiss a frog?

2098 **WYR** take a magic pill that will make you smarter or more attractive to others?

2099 **WYR** listen to music from Darius Rucker's solo career or when he was with Hootie and the Blowfish?

2100 **WYR** be someone's muse or discover your own muse?

2101 **WYR** live somewhere it's always windy or no wind at all ever?

2102 **WYR** be more aggressive or more passive?

2103 **WYR** only use hand sanitizer or only be able to use soap and water to clean your hands?

2104 **WYR** always hear birds chirping or always smell fresh flowers out your window?

2105 **WYR** only be allowed to eat the toppings off pizza or only allowed to eat crust?

2106 **WYR** listen to Adam Lambert covering Queen or listen to the original Freddy Mercury Queen?

2107 **WYR** clean up trash along the highway or clean up litter on the beach?

2108 **WYR** make a burrito with everything from your refrigerator in it or a soup with everything from your pantry in it?

2109 **WYR** live a glamorous or meaningful life?

2110 **WYR** drink Coke with chocolate syrup or Pepsi with vanilla syrup?

2111 **WYR** eat all your food super spicy or bland?

2112 **WYR** take a writing or self-defense class?

2113 **WYR** live like the Flintstones or Jetsons?

2114 **WYR** chicken noodle soup or NyQuil when you don't feel well?

2115 **WYR** drink only floats or milkshakes?

2116 **WYR** watch your TV shows as they air, or binge watch all your shows?

2117 **WYR** try Weight Watchers or paleo lifestyle if you needed to lose weight?

2118 **WYR** have the perfect weekend or a good week at work?

2119 **WYR** always hang out with a group of friends or hang out with one special friend?

2120 **WYR** have your toilet overflow every time you flush it or your refrigerator smell like rotting fish every time you open it?

2121 **WYR** always keep your phone on vibrate or always keep the ringer on (one or the other)?

2122 **WYR** have a Texan accent and live in New York or have a New York accent and live in Texas?

2123 **WYR** be able to explore a volcano or newly discovered ancient ruins?

2124 **WYR** live in doubt or live in fear?

2125 **WYR** always feel rested or always feel motivated?

2126 **WYR** potato sack race or three-legged race?

2127 **WYR** have the ability to control machines or control electricity?

2128 **WYR** have invincibility or immortality?

2129 **WYR** not be afraid of dying or not be afraid of living up to your full potential?

2130 **WYR** find an alligator or an alligator snapping turtle on your front porch?

2131 **WYR** plant rose bushes or fruit trees around your home?

2132 **WYR** be a humanitarian or philanthropist?

2133 **WYR** have a magic button that erases songs you hate or bad movies from being released?

2134 **WYR** take a step back and reflect or leap two steps forward?

2135 **WYR** eat tootsie pops or jolly ranchers?

2136 **WYR** give your friend a false alibi to police or cover for them when their spouse asks questions?

2137 **WYR** there be more diversity in cover models' body types or more women directors in Hollywood?

2138 **WYR** a spouse that cooks great or stays physically fit?

2139 **WYR** have only fried or only baked food?

2140 **WYR** be a big fish in a small pond or a small fish in a big pond?

2141 **WYR** drink homemade lemonade or fresh squeezed orange juice?

2142 **WYR** have an annoying ringtone or embarrassing screensaver?

2143 **WYR** never face consequences or challenges?

2144 **WYR** increase human life span or increase quality of life for humans?

2145 **WYR** people have more patience with each other or more wisdom in their actions?

2146 **WYR** lose all the money you have in the bank right now or lose all your friends?

2147 **WYR** be guaranteed perfect health for the next 10 years or guaranteed all your bills will be paid for the next 20 years?

2148 **WYR** have more confidence or more friends?

2149 **WYR** love yourself more or be able to open up to other people more?

2150 **WYR** have the discipline of a ballerina or the focus of a skilled surgeon?

2151 **WYR** have the chance to attend Julliard or Harvard?

2152 **WYR** your home have a revolving door to a hidden room or a secret tunnel to somewhere unknown?

2153 **WYR** be forced to live underground or as a recluse the rest of your life?

2154 **WYR** hang out with Winnie the Pooh or Curious George?

2155 **WYR** have a missed opportunity or miss a chance at love?

2156 **WYR** get a do over with a person or a second chance at a past mistake?

2157 **WYR** have eight arms like an octopus or the all-seeing Eye of Providence?

2158 **WYR** get a chance to meet Hercules or Cleopatra?

2159 **WYR** live with Aborigine people or a Zulu tribe for a week?

2160 **WYR** have your own personal manicurist or car detailer?

2161 **WYR** have a hen that lays golden eggs or a money tree?

2162 **WYR** have James Earl Jones or Arnold Schwarzenegger as the voice of your GPS mapping system?

2163 **WYR** get lost in the world of *The NeverEnding Story* or *The Secret of NIMH*?

2164 **WYR** go on Shark Tank and present an idea to the investors or accept help from Marcus Lemonis on *The Profit* but give up 65% of your company?

2165 **WYR** people constantly gossip about you or never notice you at all?

2166 **WYR** make sacrifices for people you love or only for yourself?

2167 **WYR** try your hand at glass blowing or making pottery?

2168 **WYR** make a few changes to your current life or create a whole new one?

2169 **WYR** have more happiness in your day or more energy to get through your day?

2170 **WYR** have a school or a street named after you?

2171 **WYR** have all your problems solved or have one of your dreams come true?

2172 **WYR** have more technology or less technology in your life?

2173 **WYR** have your entire house or your car completely touch screen?

2174 **WYR** play in a mariachi band or a jug band for one day?

2175 **WYR** eat only salty food or only sweet food for a year?

2176 **WYR** never wear gold or never wear silver again?

2177 **WYR** work in an office that's too bright or too dark?

2178 **WYR** chug a gallon of the hottest hot sauce with no milk or get pepper sprayed in the face for 2 minutes straight?

2179 **WYR** Stan Lee or Jackie Chan direct a fight scene you're in?

2180 **WYR** look better in pictures or better in person?

2181 **WYR** have constant brain freeze or teeth chattering?

2182 **WYR** have accidentally hit your thumb with a hammer or stick a thumbtack through your finger?

2183 **WYR** double your life span or cut your enemy's life span in half?

2184 **WYR** be allergic to rain or sunshine?

2185 **WYR** act without thinking or think without acting?

2186 **WYR** have more good habits or more education?

2187 **WYR** have unlimited access to Warren Buffet or Charles Koch for advice?

2188 **WYR** sing in the shower or sing in the rain?

2189 **WYR** ride in a paddle boat with your sweetie or stand up paddle board together?

2190 **WYR** have a celebrity personal trainer or your own life coach?

2191 **WYR** be more like a kid again or more polished and mature?

2192 **WYR** read more books or watch less TV?

2193 **WYR** eat a piece of raw meat or swallow 10 pieces of gum?

2194 **WYR** a speech bubble appeared when you talk or a flame appear on your head when you're attracted to someone?

2195 **WYR** only be able to eat with a fork or only with a spoon?

2196 **WYR** have Scooby Doo or Garfield as a pet?

2197 **WYR** slave away at a job 9-5 or hustle on your own 24/7?

2198 **WYR** have your significant other or one of your parents as your best friend?

2199 **WYR** have superfast reading or typing ability?

2200 **WYR** be able to bend your body like a snake or squeeze through tight places like an octopus?

2201 **WYR** lose feeling in your legs or arms for a week?

2202 **WYR** have a useless talent or no talent at all?

2203 **WYR** come across Hogzilla or the legendary Irish elk on your next camping trip?

2204 **WYR** someone give you a reality check or a hug every day?

2205 **WYR** have the prose of Robert Frost or creativity of Maya Angelou?

2206 **WYR** sell all of your possessions in a garage sale or donate them to people?

2207 **WYR** have 5 international plane tickets or 20 domestic plane tickets?

2208 **WYR** have immunity from speed limits and drive as fast as you want or have a police escort every time you run late?

2209 **WYR** be able to communicate with animals and have them help you when you're in need or have your favorite pet live as long as you do?

2210 **WYR** movie theaters have better food or more comfortable seats?

2211 **WYR** take a vacation away from people or have a huge family vacation?

2212 **WYR** always hope for the best or prepare for the worst (you only get one)?

2213 **WYR** be a whistleblower or a confidential informant?

2214 **WYR** only be allowed to write in calligraphy or round hand?

2215 **WYR** have revenge or justice?

2216 **WYR** try sumo wrestling or capoeira?

2217 **WYR** have your home be wall-to-wall mirrors or glow-in-the-dark paint?

2218 **WYR** retire in Hawaii or where you live right now?

2219 **WYR** bite an uncooked potato or Brussels sprout?

2220 **WYR** have a vintage Vespa in mint condition or vintage designer couture?

2221 **WYR** relax in a hammock with all your favorite things or relax lying on a beach?

2222 **WYR** seek advice from an online chat room or group therapy?

2223 **WYR** live with the residents from Mayberry or Smallville?

2224 **WYR** keep rock-n-roll alive or the music industry come up with a new genre?

2225 **WYR** be able to walk upside down on ceilings or be able to walk through walls?

2226 **WYR** hug or hip bump everyone you meet?

2227 **WYR** be given a good job through nepotism you didn't earn or work your way through the ranks and earn your position?

2228 **WYR** go to jail for a crime you committed or blame the crime on your best friend and get off without punishment?

2229 **WYR** get rid of puppy mills or lab rats?

2230 **WYR** spend a week in a Scientology retreat or a month in a Buddhist temple?

2231 **WYR** find a black widow or tarantula under your covers?

2232 **WYR** have people you can trust or a survival kit if you get caught in a zombie Apocalypse?

2233 **WYR** only order from places that can be delivered or places close enough to walk to?

2234 **WYR** live on Old MacDonald's farm or at Little Red Riding Hood's grandma's house?

2235 **WYR** visit Seattle's gum wall or the National Museum of Funeral History?

2236 **WYR** have more faith in yourself or more faith in humanity?

2237 **WYR** stay in a 5-star hotel with free room service or free spa services?

2238 **WYR** have more inspiration or less procrastination in your life?

2239 **WYR** never have another dropped call or clogged toilet?

2240 **WYR** save all the lint you find in your belly button until you die or always smell lint at a public laundromat?

2241 **WYR** have an extra bellybutton or third nipple?

2242 **WYR** have more relaxation or more opportunities in your life?

2243 **WYR** your mom have another child at her age now or your dad go through an embarrassing midlife crisis?

2244 **WYR** lose all your fingers on one hand or all your toes on one foot?

2245 **WYR** be the person who cures cancer or be immune to all cancers?

2246 **WYR** watch a *Tom and Jerry* or *Looney Tunes* marathon on TV?

2247 **WYR** be an expert lock picker or human lie detector?

2248 **WYR** smell like a dirty ashtray or sweaty gym socks?

2249 **WYR** burp every time someone kisses you or fart every time someone hugs you?

2250 **WYR** have an escape room or Medieval Times adventure for a first date?

2251 **WYR** eat brown rice or wheat bread the rest of your life?

2252 **WYR** have bad dandruff or bad blisters on your hands and feet?

2253 **WYR** be a scapegoat at work or the black sheep of your family?

2254 **WYR** your plants or your goldfish talk to you?

2255 **WYR** have a snake slither up your toilet while you pee or a flying cockroach land on your open mouth while you sleep?

2256 **WYR** be someone's alibi for a crime or the reason someone gets fired from work?

2257 **WYR** live in the suburbs or heart of the city?

2258 **WYR** eat only canned soup or boxed macaroni and cheese?

2259 **WYR** your fingers stained permanently orange from Cheetos or blue from the toilet bowl cleaner?

2260 **WYR** win the lottery tomorrow and be broke in a year or not win and continue your life?

2261 **WYR** never be able to go outside during the day again or outside at night again?

2262 **WYR** live in a small home with tons of windows or a large home with no windows?

2263 **WYR** live without spellcheck or autocorrect?

2264 **WYR** only drink diet drinks or only eat fat free foods?

2265 **WYR** have tennis shoes with jets or bionic springs?

2266 **WYR** have acne that looks like cake sprinkles or corn kernels?

2267 **WYR** have good sportsmanship or the mind-set that winning is the only thing?

2268 **WYR** work for Oprah or Lori Greiner?

2269 **WYR** eat Jell-O covered in tarter sauce or bananas covered in ketchup?

2270 **WYR** only wear Converse or Nike?

2271 **WYR** have one zit the size of a walnut or 3 zits the size of grapes?

2272 **WYR** live in the paranormal city of Bannack, Montana or the abandoned ghost town of Bodie, California?

2273 **WYR** try spear fishing or fly fishing?

2274 **WYR** have detective Adrianne Monk or the team from *Psych* helping you solve a case?

2275 **WYR** visit the Witch House of Salem or Museum of Death?

2276 **WYR** take a group of friends to play Laser Tag or to an Escape Room?

2277 **WYR** start a fan club or experiment with body painting?

2278 **WYR** make your own cheese or candles?

2279 **WYR** work at the creepy Mutter Museum or be a security guard at Trans-Allegheny Lunatic Asylum?

2280 **WYR** go noodling for catfish or start a beetle collection?

2281 **WYR** decorate your home with Impressionism or Abstract artwork?

2282 **WYR** create a cookbook with only healthy recipes or only family recipes from present and past generations?

2283 **WYR** have your favorite pet stuffed by taxidermy after it dies, or have it cremated, and you keep their ashes?

2284 **WYR** wear a jacket covered in zippers or sequins?

2285 **WYR** be a penguin or an otter?

2286 **WYR** get rid of smog or dust?

2287 **WYR** pass gas that smells like bleach or Pine-Sol?

2288 **WYR** live up to your full potential or just do your best to be happy?

2289 **WYR** be a suspect in a murder investigation or be accused of insider trading?

2290 **WYR** compete in Tough Mudder or a log rolling competition?

2291 **WYR** wear sweaters in the summer or shorts in the winter?

2292 **WYR** wear boots to the beach or sandals in the snow?

2293 **WYR** have a talking refrigerator or talking pen?

2294 **WYR** be transported to the movie *TRON* or *Mad Max Beyond Thunderdome*?

2295 **WYR** have the fastest internet connection or strongest cell phone signal?

2296 **WYR** crash weddings or parties?

2297 **WYR** canoe down the Amazon or Nile river?

2298 **WYR** experience the transformation of a caterpillar or have a day in the life of a ladybug?

2299 **WYR** walk around flexing your muscles for no reason or clicking your heels while shouting yippee?

2300 **WYR** wear a raincoat or parka for no reason?

2301 **WYR** leave your fortune to charity or to your family?

2302 **WYR** wash your parent's laundry or clean their bathroom?

2303 **WYR** never have to wake up early or never watch what you eat again?

2304 **WYR** eat vanilla or chocolate flavored everything?

2305 **WYR** go to jail or be homeless the rest of your life?

2306 **WYR** someone dedicate a book to you or name their child after you?

2307 **WYR** spend the night in a morgue or at a bus stop?

2308 **WYR** network with millionaires or have a billionaire read your next business plan?

2309 **WYR** host a family reunion or holiday dinner?

2310 **WYR** play Bingo or ice breaker games at your next party?

2311 **WYR** feel good mentally or physically?

2312 **WYR** share your food with your significant other or eat their food?

2313 **WYR** have more endurance or a more positive outlook?

2314 **WYR** date someone shorter or taller than you?

2315 **WYR** use gym equipment after a sweaty person or share a towel with someone who smells bad?

2316 **WYR** be too sensitive or lack sensitivity?

2317 **WYR** date two people at once or date someone from your past that didn't work out?

2318 **WYR** whack a piñata or whack a mole?

2319 **WYR** be trapped in an elevator with a kissing couple or sit next to a person in a packed movie theater who smells?

2320 **WYR** have beautiful eyes or kissable lips?

2321 **WYR** play by the rules or break the rules for a good reason?

2322 **WYR** have the best dance moves or the best pickup lines?

2323 **WYR** have your electricity cut off or your cellphone disconnected for the weekend?

2324 **WYR** make out in a classroom or movie theater?

2325 **WYR** be able to prevent suicide or homicide?

2326 **WYR** give up your significant other or your pet?

2327 **WYR** start over with a completely different childhood you can create or keep your current childhood memories as they are?

2328 **WYR** have your eyes change color (full color spectrum) based on your mood or your nose grow when you lie?

2329 **WYR** give up buying designer labels or owning luxury cars forever?

2330 **WYR** hang out with people you've always wanted to or people who make you look good?

2331 **WYR** be a trendsetter or record breaker?

2332 **WYR** be admired for your originality and style or for your personality?

2333 **WYR** recreate the dance from *Risky Business* or *Footloose* at your work?

2334 **WYR** eat exotic game meat or a Chinese century egg?

2335 **WYR** be an extravagant or frugal spender?

2336 **WYR** work from home or work in an office setting?

2337 **WYR** lose your luggage or your cell phone while at the airport?

2338 **WYR** have a short temper or be a complete pushover?

2339 **WYR** the human race be automatically healthy or smart?

2340 **WYR** eat a pizza overloaded with anchovies or pineapples?

2341 **WYR** Edward Scissorhands or Wolverine give you your next haircut?

2342 **WYR** have your money back on every bad purchase you've ever made or all the coins at the bottom of a wishing fountain?

2343 **WYR** have a winning show dog or a champion breeding bull?

2344 **WYR** ban people from wearing UGG boots or fanny packs?

2345 **WYR** make all your decisions by a flip of a coin or an even/odd roll of the dice?

2346 **WYR** be protected by John McClane or Robocop when you go into witness protection?

2347 **WYR** only ever use Apple products or use only their competitors but never Apple?

2348 **WYR** save all your pennies or just throw them away?

2349 **WYR** go camping during a heatwave or hiking during a big storm?

2350 **WYR** have The Rock or John Cena as your bodyguard?

2351 **WYR** switch jobs with your postal worker or garbage collector for a day?

2352 **WYR** coach a little league or be a troop leader for boy/girl scouts?

2353 **WYR** tell your best friend if you saw their significant other kissing someone else or never tell them?

2354 **WYR** slide face first down a slip-n-slide covered in whale blubber or fresh fertilizer?

2355 **WYR** be an entertainer on a cruise ship or casino?

2356 **WYR** have "the birds and bees" talk with your child or have your spouse do it?

2357 **WYR** taste a stranger's sweat or eat their booger?

2358 **WYR** marry someone introverted or extraverted?

2359 **WYR** never be allowed to drive faster than 40mph or never be allowed to drive at night again?

2360 **WYR** never lose hope or never lose faith?

2361 **WYR** be in Michael Jackson's "Thriller" video or Drake's "Hotline Bling" video?

2362 **WYR** prevent all animal extinction or be able to select what goes extinct and what propagates?

2363 **WYR** become more like your mother or father?

2364 **WYR** talk too loud or not loud enough?

2365 **WYR** forgive and forget or hold major grudges?

2366 **WYR** have the freedom to kill at will or bring people back from the dead?

2367 **WYR** give everyone you meet dab or a high five?

2368 **WYR** be on *The Office* or *Saturday Night Live*?

2369 **WYR** be besties with Shrek or Puss in Boots?

2370 **WYR** eat only Frosted Flakes or Fruity Pebbles?

2371 **WYR** have nothing copyright protected, or nothing patent protected?

2372 **WYR** be able to sleep through anything or be an extremely light sleeper?

2373 **WYR** go back in time and prevent the Titanic from sinking or prevent the bombing of Pearl Harbor?

2374 **WYR** have a friend that's a jerk or one that's a loser?

2375 **WYR** be as fast as The Flash or as strong as Superman?

2376 **WYR** blame someone else for your stinky fart or own it?

2377 **WYR** taste your own ear wax or smell a construction worker's feet?

2378 **WYR** never say another swear word again or say way too many swear words in daily conversations?

2379 **WYR** be a sweet nerd or a mean jock?

2380 **WYR** flirt with your best friend's significant other or your significant other's best friend?

2381 **WYR** always eat Girl Scout cookies or Keebler Elf cookies?

2382 **WYR** say daily affirmations or daily prayers?

2383 **WYR** walk around yelling peek-a-book or trick-or-treat?

2384 **WYR** be a no-nonsense person or have some nonsense?

2385 **WYR** never be able to use a car alarm or home alarm?

2386 WYR have chicken pox that last a month or mumps that last two months?

2387 WYR only be able to listen to music on vinyl or cassette?

2388 WYR find a message in a bottle or a small unopened box floating at the beach?

2389 WYR write for the game *Cards Against Humanity* or write the puzzles for *Wheel of Fortune*?

2390 WYR play beer pong or charades at your next party?

2391 WYR get paid to be in a relationship with someone to make them popular or paid to get into shape?

2392 WYR have one wish granted now or wait and have 3 wishes granted in 10 years?

2393 WYR spend more of your money on clothes or traveling the world?

2394 WYR date a person who was previously in a mental institution but is ok now or someone who was infamous in a viral video?

2395 WYR take a personality test or a pop quiz?

2396 WYR be the bread winner for your family or be the stay at home parent?

2397 WYR be a morning person or night owl?

2398 WYR go to a Steven Spielberg or Alfred Hitchcock film festival?

2399 WYR rekindle an old relationship or get closure from a bad breakup?

2400 WYR be protected from identity theft forever or never catch another cold again?

2401 **WYR** mine for diamonds or gold?

2402 **WYR** belong to Mensa or the Freemasons?

2403 **WYR** marry someone with different beliefs or someone who has different views on having kids?

2404 **WYR** have an indestructible car or home?

2405 **WYR** drink coffee out of a random person's shoe or eat the slime found in an ice machine?

2406 **WYR** your dream house have breathtaking views out every window or have the best location and convenience?

2407 **WYR** wear a tutu and a fake mustache or a veil and biker jacket everywhere you go?

2408 **WYR** have piano lessons from Elton John or Billy Joel?

2409 **WYR** the media expose more corruption or honor more heroes?

2410 **WYR** relive your first kiss or your first date?

2411 **WYR** try to get out of handcuffs or a straitjacket?

2412 **WYR** be able to walk on water or swim beneath the water without needing air?

2413 **WYR** backpack through Europe or horseback through the Grand Canyon?

2414 **WYR** own a record label or a movie studio?

2415 **WYR** learn how to play the bongos or a ukulele?

2416 **WYR** take a vow of poverty or vow of celibacy?

2417 **WYR** smash pumpkins or watermelons off the top of a building?

2418 **WYR** your jeans fit too loosely or too tight?

2419 **WYR** have an everlasting car battery or flashlight that never dims?

2420 **WYR** max out all your credit cards but have everything you want for now or save your credit cards for emergencies but live in want?

2421 **WYR** only be allowed to wear skinny jeans or all other jeans but no skinny jeans?

2422 **WYR** eat turtle soup or hasenpfeffer?

2423 **WYR** get a tan from a spray bottle or tanning bed?

2424 **WYR** dress up like cupid every Valentine's Day or never celebrate Valentine's Day again?

2425 **WYR** kiss a used toilet plunger or eat dry bird poop?

2426 **WYR** keep a fish or plant on your work desk?

2427 **WYR** be stuck on the same level of your favorite game for a month or have no access to your favorite game for a month?

2428 **WYR** get caught wearing unmatched socks or socks with holes in them?

2429 **WYR** have the theme song to *Halloween* or *Jaws* stuck in your head?

2430 **WYR** pop fireworks or get drunk for New Year's?

2431 **WYR** have your jaws wired shut for a month (drinking only out of a straw) or wear an eye patch for a year?

2432 **WYR** create your own magic potions or be immune to venom and poison?

2433 **WYR** rid the world of corruption or greed?

2434 **WYR** get rid of *TMZ* or *PopSugar* gossip site?

2435 **WYR** be able to hear other people's thoughts or sense fear in anyone?

2436 **WYR** be remembered as a great philosopher or warrior?

2437 **WYR** become more ambitious or resourceful?

2438 **WYR** play a competitive game of Red Rover or musical chairs?

2439 **WYR** follow your gut instinct or listen to your heart?

2440 **WYR** take your pet or most of your possessions but not your pet if your house caught on fire?

2441 **WYR** live on the East Coast or West Coast?

2442 **WYR** have a *Jenga* or *Twister* contest?

2443 **WYR** see a dead animal or poop floating in a pool you're swimming in?

2444 **WYR** smell something foul under your bed or coming from the trunk of your car?

2445 **WYR** trade houses with one of your neighbors or your parents?

2446 **WYR** bring back rotary phones or classic typewriters for use?

2447 **WYR** participate in a 24-hour marathon of karaoke or swing dancing?

2448 **WYR** have Columbo or Matlock on the case if you were murdered?

2449 **WYR** have a church wedding or a destination wedding?

2450 **WYR** drive a zeppelin or a parasail in a dinosaur suit?

2451 **WYR** runaway to Nashville or Hollywood?

2452 **WYR** be forced to wear all polka dots or all paisley every day?

2453 **WYR** have a heart of gold or stone?

2454 **WYR** only get hand me down clothes from family and friends or only buy your clothes from garage sales?

2455 **WYR** the dreams (good & bad) you have had while sleeping come true or a movie that scared you as a kid become a reality?

2456 **WYR** drive a motorcycle in the ring of death or jump it through a ring of fire?

2457 **WYR** go camping on the beach or in the woods?

2458 **WYR** learn how to throw a boomerang or play a didgeridoo?

2459 **WYR** give people the gift of love or laughter?

2460 **WYR** only wear designer shoes or sunglasses?

2461 **WYR** be the frog in *Frogger* or Mario in *Mario Bros.*?

2462 **WYR** be a pig farmer or snake charmer?

2463 **WYR** have breakfast at Tiffany's or with the Breakfast Club?

2464 **WYR** lick your bathroom floor or the outside of your car windows?

2465 **WYR** host the Oscars or the MTV Music Awards?

2466 **WYR** always travel by boat or always by plane?

2467 **WYR** try and swing on a trapeze or walk on a high tightrope?

2468 **WYR** explore unknown parts of the ocean or unknown parts of space?

2469 **WYR** top your burger with frog legs or sea urchin?

2470 **WYR** help an elderly person or blind person cross the street?

2471 **WYR** be given an honorary doctorate or earn a master's degree?

2472 **WYR** go back and meet "The Man in Black," Johnny Cash or "the King," Elvis Presley?

2473 **WYR** collect toy donations for kids or gather letters and care packages for soldiers this coming Christmas?

2474 **WYR** get fired from your job if it meant 10 people could keep their job or keep your job and 10 people lose their job?

2475 **WYR** eat healthy or eat whatever you want?

2476 **WYR** go on a stakeout or participate in a walkout?

2477 **WYR** be an interior designer or graphic designer?

2478 **WYR** always play it safe or be a risk taker?

2479 **WYR** give up millions if it would break up your family or keep the money and lose the family?

2480 **WYR** do a total gym flow or only work out when you have time?

2481 **WYR** squeeze a stress ball or pop bubble wrap when you feel stress?

2482 **WYR** always decide for yourself or have others decide for you?

2483 **WYR** take a leap of faith or wait for a sign?

2484 **WYR** tell your mate what you want for your birthday or let them surprise you however they want?

2485 **WYR** a Double-Double from In-N-Out be served with fries or a milkshake?

2486 **WYR** barbeque with charcoal or propane?

2487 **WYR** drive an Audi or a Lexus?

2488 **WYR** have glowing skin or healthy hair?

2489 **WYR** have more sunny or cloudy days?

2490 **WYR** drive a family van or family station wagon?

2491 **WYR** be in the play *12 Angry Men* or *To Kill a Mockingbird?*

2492 **WYR** interview people on the red carpet or get interviewed on the red carpet?

2493 **WYR** embrace drama or avoid drama?

2494 **WYR** eat cheddar popcorn or kettle corn?

2495 **WYR** spend your life on the run as a fugitive or surrender for a lighter sentence but still do hard time?

2496 **WYR** sit in the front or back of the rollercoaster?

2497 **WYR** work for Dr. Doolittle or Ace Ventura?

2498 **WYR** eat soldier field rations or Twinkies to survive?

2499 **WYR** do the "Whip/Nae Nae" or "Gangnam Style" dance every time someone says your name?

2500 **WYR** have your own pumpkin patch or strawberry field?

2501 **WYR** run out of gas or get a flat tire on an abandoned road?

2502 **WYR** eat a pizza covered in anchovies or a pizza with no cheese?

2503 **WYR** get a full-bodied tattoo that is temporary or one the size of a baseball that is real?

2504 **WYR** have a *Forrest Gump* adventure or *Cast Away* adventure?

2505 **WYR** march in protest or stand in solidarity?

2506 **WYR** work for *Sports Illustrated* or *Vogue*?

2507 **WYR** collect rare art or expensive wine?

2508 **WYR** rehab injured wildlife or help clean up the environment?

2509 **WYR** walk on your hands when you go to the restroom or crab crawl through the grocery store?

2510 **WYR** fast for 30 days or eat only McDonald's for 60 days each meal?

2511 **WYR** enforce the law or break the law?

2512 **WYR** try balut or durian fruit?

2513 **WYR** live in an aerial tram for a month or a yurt for a year?

2514 **WYR** spend the night in a scary abandoned building or crack walnuts with your elbow only?

2515 **WYR** find living relatives you don't know about or learn more about your significant other's family history?

2516 **WYR** be an ichthyologist or botanist?

2517 **WYR** eco friendly home or a smart home?

2518 **WYR** play in a mahjong or dominos tournament?

2519 **WYR** touch a star or the moon's surface?

2520 **WYR** eat only TV dinners or sandwiches for a year?

2521 **WYR** skip 5 years' worth of holidays or 5 birthdays in a row?

2522 **WYR** own a piece of a space shuttle or a rock from outer space?

2523 **WYR** ground or spank your child for discipline?

2524 **WYR** swim with a blue whale or have free admission to Sea World the rest of your life?

2525 **WYR** have the perfect abs or a perfect smile?

2526 **WYR** be radioactive or a haemophiliac?

2527 **WYR** get pinched by 50 crabs or 100 crawfish?

2528 **WYR** babysit a crying newborn or a bratty toddler?

2529 **WYR** jump in a wingsuit or explore Jacob's Well?

2530 **WYR** serenade your crush or write them a poem?

2531 **WYR** have a job that allows you to travel the world or one that gives you security in a city you love but is monotonous?

2532 **WYR** wear adult diapers outside your clothes or wrap yourself in bubble wrap under your clothes?

2533 **WYR** weaponize your anger or make love become contagious like a virus?

2534 **WYR** better safety features or more amenities in your car?

2535 **WYR** be a better liar or listener?

2536 **WYR** wear socks with sandals or headband, wristband and leg warmers all at once?

2537 **WYR** go around tickling strangers or shine a laser pointer on people standing around outside?

2538 **WYR** an eye for an eye or turn the other cheek?

2539 **WYR** free climb up the Leaning Tower of Pisa or try and balance atop the Empire State Building?

2540 **WYR** leave everything to fate or be the master of your own destiny?

2541 **WYR** call someone out for double dipping or chewing with their mouth open?

2542 **WYR** spike the punch or Xerox your butt at the next office party?

2543 **WYR** karaoke an Elvis or Kanye West song?

2544 **WYR** judge a book by its pages or take the time to read it?

2545 **WYR** compete on *Iron Chef* or *Chopped*?

2546 **WYR** drink a whole pot of coffee or a jug of OJ?

2547 **WYR** have an app that can hypnotize people or forces them to tell the truth?

2548 **WYR** give someone a second chance or get a second chance from someone?

2549 **WYR** get rid of nukes or terrorists?

2550 **WYR** get ringworm or tapeworm?

2551 **WYR** have a multi-tool or a survival guide on you at all times?

2552 **WYR** go to space camp or band camp?

2553 **WYR** see more butterflies or fireflies?

2554 **WYR** read *Where the Wild Things Are* or *Ferdinand the Bull* to your child as their bedtime story?

2555 **WYR** interview Norman Bates or Hannibal Lecter?

2556 **WYR** your country have better education or better healthcare?

2557 **WYR** have your own eBay or Etsy store?

2558 **WYR** have a sure thing or work for it?

2559 **WYR** pass along all the good advice you receive or keep it for yourself?

2560 **WYR** invite the Mad Hatter or Cheshire Cat to your next tea party?

2561 **WYR** feel insecure or underappreciated?

2562 **WYR** listen to heavy metal or symphony music?

2563 **WYR** be a movie critic or food critic?

2564 **WYR** be a smart person in a room full of dumb people or a dumb person in a room full of smart people?

2565 **WYR** work for a small family business or a large corporation?

2566 **WYR** always be prepared or just wing it?

2567 **WYR** have the world's most dangerous job or the world's easiest job?

2568 **WYR** break a mirror or walk under a ladder?

2569 **WYR** play horse shoes or cornhole?

2570 **WYR** wear wet underwear in the cold or gloves in the heat?

2571 **WYR** use a stranger's toothbrush or wear their underwear?

2572 **WYR** never be able to tell a lie or never complain ever again?

2573 **WYR** have the ability to make imaginary things real or shrink any object you want?

2574 **WYR** complete everything on your bucket list or spend the most time with family and friends you can before dying?

2575 **WYR** have Harry Potter or Bella Swan as your best friend?

2576 **WYR** be able to manipulate the lottery or get to choose how long others live?

2577 **WYR** live in Anoka, MN the Halloween capitol of the world or Bethlehem, PA the Christmas city?

2578 **WYR** double your current height or lose 25% of your body weight?

2579 **WYR** live in New Orleans or Atlantic City?

2580 **WYR** have unlimited coffee from Starbucks or unlimited burgers from Wendy's?

2581 **WYR** live in the poorest country or coldest country in the world?

2582 **WYR** live in a world where there is no freedom of speech or no divorce?

2583 **WYR** be a white-collar criminal or blue-collar worker?

2584 **WYR** get rid of all the internet trolls or get rid of all the fake social media accounts?

2585 **WYR** work for WikiLeaks or Anonymous?

2586 **WYR** intern for Mark Zuckerberg or Elon Musk?

2587 **WYR** know all your government's secrets or keep things as they are?

2588 **WYR** have a foreign exchange student live with you a year or host 10 homeless people for Thanksgiving?

2589 **WYR** lose the ability to see your reflection or lose feeling in all your fingertips?

2590 **WYR** have the ability to fix anything broken or ability to create new technology?

2591 **WYR** get rid of YouTube or music videos forever?

2592 **WYR** watch movies with subtitles only or watch movies with no music soundtrack?

2593 **WYR** sing the national anthem in your underwear at a major event or have a video of you shaving your head go viral?

2594 **WYR** find a village of imps or forest of dryad trees?

2595 **WYR** never get another bad gift or get invited to all the best parties?

2596 **WYR** never lose your eyesight or any of your teeth even as you age?

2597 **WYR** have an evil twin or a twin who is very boring?

2598 **WYR** have a high school experience like *The Faculty* or *Varsity Blues*?

2599 **WYR** only Instagram pics of your food or people you meet if you can't have a second IG account?

2600 **WYR** retire in 20 years and be comfortable or retire in 50 years and be loaded?

2601 **WYR** have 101 dalmatians or a singing frog?

2602 **WYR** have the scarlet letter A or the word snitch across your forehead?

2603 **WYR** only be allowed to play *Angry Birds* or *Farmville*?

2604 **WYR** be politically correct always or be yourself and it offends people?

2605 **WYR** experience love at first sight or a slow budding romance?

2606 **WYR** be allowed to slap someone in the face penalty free or spit in their drink and have them drink it?

2607 **WYR** try flamenco or belly dancing?

2608 **WYR** bite a bar of soap or a spoonful of baby vomit?

2609 **WYR** ask for permission or beg for forgiveness?

2610 **WYR** get rainbow highlights in your hair or paint your fingernails rainbow colors?

2611 **WYR** cut off half your hair or have your hair double in length right now?

2612 **WYR** be woken up by an air horn or chainsaw?

2613 **WYR** see everything in polka dots or stripes?

2614 **WYR** save a stranger or your pet from death?

2615 **WYR** be photographed buying something embarrassing or when you look at your worst and it get posted online?

2616 **WYR** wear your grandmother's stockings or one of her wigs?

2617 **WYR** a slice of cake or slice of pie?

2618 **WYR** a quiet birthday dinner with your boo or a huge surprise birthday bash?

2619 **WYR** shovel snow or rake leaves?

2620 **WYR** read private employee files at your job or celebrity arrest record details?

2621 **WYR** meet the cast of your favorite TV show or the private number of a celebrity you like?

2622 **WYR** only ever eat food out of a can or only eat frozen food?

2623 **WYR** have the opportunity to confront someone who wronged you or apologize in a special way to someone you wronged?

2624 **WYR** eat food with too much salt or no salt at all?

2625 **WYR** your voice sound like you just sucked helium or sound like the great and powerful Oz?

2626 **WYR** have Oreos or French fries be calorie free?

2627 **WYR** be able to prevent any future bad relationships or prevent bad karma?

2628 **WYR** have Gadhafi or Castro as the leader of your country?

2629 **WYR** be able to do any dance move perfectly or impersonate anyone's voice?

2630 **WYR** test fireproof clothing or be an attack dog dummy?

2631 **WYR** only have friends the opposite gender or the same gender as you?

2632 **WYR** be book smart but have no common sense or street smart but have no higher education?

2633 **WYR** have more muscle and strength or more flexibility and longer legs?

2634 **WYR** catch the flu virus or your laptop get a bad computer virus?

2635 **WYR** drive a Mercedes Benz or BMW?

2636 **WYR** not be able to find a job for two years or work a job that violates your principles?

2637 **WYR** have a celebrity follow you back on Instagram or your crush send you a Facebook friend request?

2638 **WYR** get rid of cable TV or boxing?

2639 **WYR** revive MC Hammer's or the band Sugar Ray's music career?

2640 **WYR** find out you were related to Hitler or Osama Bin Laden?

2641 **WYR** kiss your neighbor or the last person to email you?

2642 **WYR** revive Pee Wee Herman's or Pauly Shore's acting career?

2643 **WYR** only play games on PC or console?

2644 **WYR** rid the world of Nutella or pumpkin spice products?

2645 **WYR** marry a stranger or a distant cousin for only a year?

2646 **WYR** never buy anyone another gift or never pay anyone another compliment?

2647 **WYR** steal something from your work or the grocery store?

2648 **WYR** read Steve Jobs' or Bill Gates' private journals?

2649 **WYR** get rid of Twitter or LinkedIn?

2650 **WYR** improve the lunch in public schools or ban kids under 12 from eating fast food?

2651 **WYR** have supportive or brutally honest friends?

2652 **WYR** follow your significant other or hire a private detective if you thought they were cheating?

2653 **WYR** always have a bad taste in your mouth or your stomach always growl even after you've just eaten?

2654 **WYR** dance in the rain or have a snowball fight in the snow?

2655 **WYR** rollerblade down a freeway or Segway through Central Park?

2656 **WYR** smoke a cigar or a hookah pipe?

2657 **WYR** be forgetful or stutter when you speak?

2658 **WYR** listen to music on Spotify or iTunes?

2659 **WYR** eat protein bars or drink protein shakes?

2660 **WYR** buy Bose or Beats headphones?

2661 **WYR** wear fringe on everything or dress leather head to toe?

2662 **WYR** someone break up with you over the phone or by taking you out for one last dinner date?

2663 **WYR** be a freeloader or free spirit?

2664 **WYR** spend your vacation catching up on rest and personal tasks or treat yourself to a cruise?

2665 **WYR** play *Dance Dance Revolution Arcade* or *Guitar Hero*?

2666 **WYR** your clothes be comfortable or trendy?

2667 **WYR** ask for directions or try and find it on your own?

2668 **WYR** your bank statement or text history get posted to your social media?

2669 **WYR** be spontaneous or predictable?

2670 **WYR** never wear leather products again or give up caffeine?

2671 **WYR** meet George Washington or Abraham Lincoln?

2672 **WYR** be called kind or cute?

2673 **WYR** have someone make your bed for you every day or someone buy you lunch every day?

2674 **WYR** spend more time outdoors or indoors?

2675 **WYR** meet your favorite Olympic athlete or favorite sports team athlete?

2676 **WYR** strive for perfection or embrace your flaws?

2677 **WYR** only read traditional hardback/paperback books or only read them digitally ever again?

2678 **WYR** adopt a cat or adopt a dog?

2679 **WYR** visit Madagascar Island or Galapagos Islands?

2680 **WYR** cook the meal or do the dishes?

2681 **WYR** get stitches from a cut or break a bone, requiring a cast?

2682 **WYR** only be allowed to watch daytime TV or primetime TV?

2683 **WYR** drive a bumper car or bumper boat?

2684 **WYR** have pretzels or Twizzlers for fingers?

2685 **WYR** only be allowed to watch soap operas or game shows?

2686 **WYR** dip your fries in sriracha or mayonnaise?

2687 **WYR** sleep on a mattress you find on the side of the road or chew gum you find stuck to the bottom of your shoe?

2688 **WYR** watch golf or bowling on TV?

2689 **WYR** only be able to play RPG or sports video games?

2690 **WYR** look like the characters from *Avatar* or *The Lord of the Rings?*

2691 **WYR** call random phone numbers and strike up conversations or sniff random people on the street?

2692 **WYR** have a big office in an old building or small office in new building?

2693 **WYR** brush your teeth with motor oil or cat litter?

2694 **WYR** stick a hot pepper up your nose or drink an entire jar of pickle juice?

2695 **WYR** have a car with bad gas mileage or no radio?

2696 **WYR** burp the alphabet in public or wear a kiss me sign all day?

2697 **WYR** have the power to make anyone fall in love with you or obey you?

2698 **WYR** tell your best friend you don't like their current significant other or say nothing?

2699 **WYR** spend your day watching reruns or putting together jigsaw puzzles?

2700 **WYR** make your own bread or make your own pasta?

2701 **WYR** go all day with your clothes inside out or dance on top of a public bus stop?

2702 **WYR** howl like a wolf when you order your lunch or pay for your lunch using only coins?

2703 **WYR** practice kissing with a stuffed animal or your hand in public?

2704 **WYR** live off ramen noodles or Chef Boyardee for a month?

2705 **WYR** have your face printed on money or your own small town named in your honor?

2706 **WYR** never need sleep or food again?

2707 **WYR** lose the ability to learn new things (you'll keep what you already know) or have the inability to forget anything?

2708 **WYR** have a fireplace or jacuzzi in your bedroom?

2709 **WYR** watch only the History or Discovery channel for a month?

2710 **WYR** spill food on your clothes every time you eat or trip every time you wear shoe laces?

2711 **WYR** spring break in Miami Beach or Cancun?

2712 **WYR** go to a random person's Facebook profile and like all their posts going a year back or pick your best friend's nose?

2713 **WYR** get rid of Kit Kat or Snickers?

2714 **WYR** drink only iced coffee or hot coffee?

2715 **WYR** go to your ex's or enemy's wedding?

2716 **WYR** debate Piers Morgan or Jon Stewart?

2717 **WYR** live in North Korea or Russia?

2718 **WYR** always eat out alone or never get enough alone time?

2719 **WYR** have the ability to give people happiness or health?

2720 **WYR** not have enough money to buy a wedding ring or take a honeymoon?

2721 **WYR** have Jason Bourne or Bryan Mills rescue you if you're kidnapped?

2722 **WYR** have a shopping spree at Target or Walmart?

2723 **WYR** wear a suit to bed or pajamas at work?

2724 **WYR** reveal to your new in-laws the meanest thing you've ever done or any crimes you may have committed?

2725 **WYR** never have another regret or never worry again?

2726 **WYR** have to ask your parents' permission even as an adult or consult a psychic for every big decision?

2727 **WYR** have a real Italian pizza oven or wine cellar in your home?

2728 **WYR** your cell phone have real conversations with you or give you good advice?

2729 **WYR** only drive stick shift or never drive stick shift?

2730 **WYR** grow up in the Prohibition Era or Civil Rights Era?

2731 **WYR** wear uncomfortable underwear or shoes?

2732 **WYR** survive WW3 with limited resources or spend the rest of your life living in an RV?

2733 **WYR** never have another phobia or never cry again?

2734 **WYR** be part of the family from *The Simpsons* or *Family Guy*?

2735 **WYR** get a million dollars but you'll never be able to receive any more money or take $100,000 now and life resumes as normal?

2736 **WYR** post a really bad selfie as your Facebook profile photo or post a video of you licking a tire to your social media accounts?

2737 **WYR** be a hoarder or janitor?

2738 **WYR** always pick truth or pick dare in truth or dare?

2739 **WYR** bring back the original Atari or payphones?

2740 **WYR** Criss Angel or David Blaine perform at your next party?

2741 **WYR** practice vampirism or be part of a polygamist community?

2742 **WYR** always say what's on your mind or always bite your tongue?

2743 **WYR** never have another bad selfie or bad hair day?

2744 **WYR** never do laundry or dishes again?

2745 **WYR** shower with your clothes on or jog in the buff?

2746 **WYR** eat Sour Patch Kids or M&M's?

2747 **WYR** play shuffleboard or air hockey?

2748 **WYR** see a hair in your food or a roach under your table at a restaurant?

2749 **WYR** only sleep on a plush twin mattress or king size air mattress?

2750 **WYR** send a mean text to all your phone contacts or have people think you're missing for 48 hours?

2751 **WYR** win every item you bid on from eBay or always have free shipping on Amazon?

2752 **WYR** tell bad knock-knock jokes to everyone you meet or talk about yourself in third person all the time?

2753 **WYR** have an unlimited supply of one thing you want or have your 15 minutes of fame?

2754 **WYR** experience life as another species or as a supernatural creature?

2755 **WYR** bring a fictional character from a book or movie to life or a cartoon character to life?

2756 **WYR** have your face freeze like your favorite emoji face or always look constipated?

2757 **WYR** sail or fly around the world?

2758 **WYR** play darts or trivia night at your favorite pub?

2759 **WYR** win a trophy or medal?

2760 **WYR** have a magic carpet or a flying broom?

2761 **WYR** cook smores or hot dogs when camping?

2762 **WYR** erase infidelity or monogamy from the planet?

2763 **WYR** cap athlete salaries or attorney's fees?

2764 **WYR** your favorite team always win or the team you hate always lose?

2765 **WYR** hang out with Kenny Powers or Ron Burgundy?

2766 **WYR** attend a NASCAR rally in a shirt that reads, "I hate NASCAR" or an anti-Trump rally in a shirt that says, "I love Trump?"

2767 **WYR** chill with Mickey Mouse or Donald Duck?

2768 **WYR** spend the day cleaning kennels at an animal shelter or changing diapers at an elderly home?

2769 **WYR** watch a remake of *Jaws* or *The Breakfast Club*?

2770 **WYR** never lose another bet again or spend a day with the wisest person on earth?

2771 **WYR** be stuck in the horror movie *Final Destination* or *Scream*?

2772 **WYR** dress in all yellow head to toe or dress in non-matching patterns and colors?

2773 **WYR** carry a doll around and pretend it's real or talk to yourself out loud in front of others?

2774 **WYR** take your mom or your best friend on an all-expenses paid shopping spree?

2775 **WYR** never have another delayed flight or never pay baggage fees again?

2776 **WYR** go line dancing or slam dancing?

2777 **WYR** break up with your current significant other or current best friend?

2778 **WYR** be envied or be admired?

2779 **WYR** have a knife or baseball bat for personal protection?

2780 **WYR** know how to drive a fork lift or 18-wheeler?

2781 **WYR** have a blanket made from bubble wrap or pillow made from foil?

2782 **WYR** have a new cellphone or new computer?

2783 **WYR** have a bad dentist visit or a bad day at work?

2784 **WYR** jump off of the Golden Gate Bridge or climb the tallest building in New York with suction hands and feet?

2785 **WYR** order 100 pizzas and send them to your enemy's house or post your ex's photo on a lost dog flyer?

2786 **WYR** not be able to stop sneezing or coughing?

2787 **WYR** always feel dizzy or always feel like someone is following you?

2788 **WYR** read ancient scrolls from Julius Cesar or old notes from Einstein?

2789 **WYR** have to always take the stairs or always take the elevator?

2790 **WYR** read the Bible or drink warm milk before bedtime?

2791 **WYR** attend a toga party or garden party?

2792 **WYR** sweat profusely or get cold very easily?

2793 **WYR** have spaghetti arms or rubber band legs?

2794 **WYR** drop your cellphone in the toilet or out a car window while in motion?

2795 **WYR** only be able to go to the movies or to restaurants (not both) for date night the next year?

2796 **WYR** be too muscular or too skinny?

2797 **WYR** always hold a grudge or always forgive easily?

2798 **WYR** share your lunch with someone less fortunate or buy them lunch?

2799 **WYR** get shampoo in your eyes or soap in your mouth?

2800 **WYR** date someone sneaky or sarcastic?

2801 **WYR** keep your Christmas decorations up (inside and out) year-round or never decorate for Christmas again?

2802 **WYR** pay off your debts or buy your parents something nice?

2803 **WYR** spend your weekends in the library or laying in bed and only reading *Wikipedia*?

2804 **WYR** read newspapers or magazines?

2805 **WYR** host a game night or movie night at your house?

2806 **WYR** belong to a country club or a book club?

2807 **WYR** keep working if you win the lottery or simply retire with your winnings?

2808 **WYR** have a squeaky clean or troublemaker image?

2809 **WYR** live without a microwave or hair blow dryer?

2810 **WYR** it forever be spring or summer?

2811 **WYR** have too much time on your hands or never enough time?

2812 **WYR** learn how to knit or take up origami?

2813 **WYR** take a dance class or a cooking class?

2814 **WYR** find a hidden amulet that opens an alternate realm, or a box of treasures and secrets left behind by your ancestors?

2815 **WYR** try a reflexology or shiatsu massage?

2816 **WYR** only be allowed to buy items on sale (if it's not on sale you can't buy it) or buy anything as long as it's not on sale?

2817 **WYR** spend all your money shopping on Amazon or eBay?

2818 **WYR** have your favorite nursery rhyme or your favorite toy as a child come to life?

2819 **WYR** start an online or brick and mortar business?

2820 **WYR** know how to lift fingerprints off things or study graphology?

2821 **WYR** pay cash for everything or charge it?

2822 **WYR** put others first or put yourself first?

2823 **WYR** never ride a bicycle again or never use a ride share service again?

2824 **WYR** be an only child or have lots of siblings?

2825 **WYR** get free lunches or longer breaks at work?

2826 **WYR** solve 10 Rubik's Cubes in under 30 mins or stack the tallest house of cards, if your life depended on it?

2827 **WYR** have a homemade or store-bought birthday cake?

2828 **WYR** be forced to attend every family reunion or gathering your family ever has or never attend a family function again?

2829 **WYR** get stung in the face by a bee or have a bug crawl deep in your ear?

2830 **WYR** have taco Tuesday every Tuesday or meatless Monday every Monday?

2831 **WYR** find a wallet and turn it in or keep it and say nothing?

2832 **WYR** walk on broken glass or over a floor covered in Legos?

2833 **WYR** watch a space shuttle launch or a landmark building implode?

2834 **WYR** be reincarnated or ascend into heaven when you die?

2835 **WYR** have unlimited cellphone battery life or an indestructible cellphone?

2836 **WYR** marry a doctor or a teacher?

2837 **WYR** be audited by the IRS or get a root canal?

2838 **WYR** be in a relationship where you always argue or have nothing in common?

2839 **WYR** always be thirsty or always be hungry?

2840 **WYR** dress like your parents or listen to their music when they were the age you are now?

2841 **WYR** have a conventional lifestyle or bohemian lifestyle?

2842 **WYR** be a hypochondriac or hypocrite?

2843 **WYR** make a time capsule or record a video message for your child after you die?

2844 **WYR** have a hand-written diary or a typed digital diary?

2845 **WYR** keep all your money in a bank or somewhere else?

2846 **WYR** be a true crime writer or romance novelist?

2847 **WYR** live in a place where it's your favorite season year-round or live in a place where you can experience all four seasons?

2848 **WYR** be dressed and ready for your day or have your house completely cleaned at the snap of your fingers?

2849 **WYR** have a compost bin or recycle bin in your home?

2850 **WYR** try extreme couponing or extreme snowboarding?

2851 **WYR** eat a bowl full of jelly beans or skittles?

2852 **WYR** your life be full of surprises or run like a well-oiled machine and be very predictable?

2853 **WYR** become mentally or physically handicapped?

2854 **WYR** have a very public or quiet and romantic engagement proposal?

2855 **WYR** train with Usain Bolt or Michael Phelps?

2856 **WYR** battle Ursula or Maleficent if you were thrown into a Disney movie?

2857 **WYR** be able to ask God a question or ask your parents anything and they must answer truthfully?

2858 **WYR** marry an ugly comedian that made you laugh constantly or super-hot model that only talked about themselves?

2859 **WYR** have Shirley Temples or pink lemonade at your next picnic?

2860 **WYR** take photos with a Canon or Nikon?

2861 **WYR** spend your life in prison or take lethal injection?

2862 **WYR** clean your grandmother's dentures or change 10 poopy diapers?

2863 **WYR** shop only at Trader Joe's or shop at all other grocery stores but not Trader Joe's?

2864 **WYR** get one ear pierced all the way up the ear or get both nostrils pierced?

2865 **WYR** *Candy Land* or *Monopoly* be real?

2866 **WYR** be called lazy or stupid?

2867 **WYR** make your parents happy or do what makes you happy?

2868 **WYR** swim in a marsh or a bayou?

2869 **WYR** sit in the front of the class or at the back of the class?

2870 **WYR** streak through a grocery store naked or go on a blind date that you cannot leave early on?

2871 **WYR** live alone or with a roommate if you're single?

2872 **WYR** take photos in black and white or color?

2873 **WYR** be a silent partner in a successful company or the face and brand in a start-up company?

2874 **WYR** raise minimum wage or improve health coverage for workers?

2875 **WYR** snoop through your neighbor's mail or window?

2876 **WYR** make a vision board or one giant to-do list?

2877 **WYR** see pigs fly or hell freeze over?

2878 **WYR** use the Apple watch or iPad?

2879 **WYR** eat warm salad or cold soup?

2880 **WYR** wear a zebra stripes or leopard spots pattern outfit?

2881 **WYR** play basketball blindfolded or play soccer in a trench coat?

2882 **WYR** take less showers or brush your teeth less?

2883 **WYR** wear a cowboy hat or sombrero every day for a week?

2884 **WYR** always play it safe or be a risk taker?

2885 **WYR** never lose your keys or your cellphone again?

2886 **WYR** be demoted or fired from a job?

2887 **WYR** be poor with rich friends or rich with poor friends?

2888 **WYR** have the life of your dreams but no one to share it with (spouse/kids) or keep your life now?

2889 **WYR** get lice or crabs?

2890 **WYR** have thick curly hair or thin straight hair?

2891 **WYR** have to drink all your drinks from a baby bottle or eat all your food from a trash can lid?

2892 **WYR** feel numb from the waist down or waist up?

2893 **WYR** be able to only choose odd numbers or even numbers?

2894 **WYR** cuddle a porcupine or snuggle a skunk?

2895 **WYR** catch snowflakes or rain drops on your tongue?

2896 **WYR** watch a game show or a reality TV show?

2897 **WYR** dine at an all-you-can-eat buffet or very expensive restaurant where there are no prices on the menu?

2898 **WYR** give in to temptation or try and resist it?

2899 **WYR** be subjected to peer pressure or be the peer that is doing the pressuring?

2900 **WYR** only watch movies in the movie theater or only at home and not in theaters?

2901 **WYR** be a part of a choir or marching band?

2902 **WYR** play Marco Polo or have a chicken fight in the pool?

2903 **WYR** do all your Christmas shopping early or wait until the last minute?

2904 **WYR** have a gym at home and never use a public gym or always use public gym and never workout at home?

2905 **WYR** eat only Chick-fil-A or KFC?

2906 **WYR** always carry a pocket knife or a multi-tool with you?

2907 **WYR** only have online relationships or only in-person relationships?

2908 **WYR** be a famous bounty hunter or well-paid recluse assassin?

2909 **WYR** have a weak bladder or weak knees?

2910 **WYR** spend the weekend cleaning out your closet or performing a community service?

2911 **WYR** have a double chin or flabby underarms?

2912 **WYR** have buffalo wings or nachos at your next party?

2913 **WYR** be stranded on the planet from *Pitch Black* or *Dune?*

2914 **WYR** only use Google Chrome or Firefox?

2915 **WYR** be able to feel pain or never feel anything at all, including good things?

2916 **WYR** someone ignore you or yell at you when they're mad at you?

2917 **WYR** take up bird watching or stamp collecting?

2918 **WYR** be a virtuous person or a pantomath?

2919 **WYR** climb a rock wall or try ice climbing?

2920 **WYR** travel to a place you always wanted to go alone or take a trip down memory lane with your family?

2921 **WYR** never buy popcorn or never buy soda at the movies again?

2922 **WYR** get pampered every Monday instead of work or be off every Friday, Saturday and Sunday?

2923 **WYR** have an empty refrigerator or an empty pantry?

2924 **WYR** never use a dishwasher again or clothes washing machine again?

2925 **WYR** your fart sound like a car backfiring or a whoopee cushion?

2926 **WYR** people think you're too good for your significant other or they're too good for you?

2927 **WYR** feed pigeons in the park or seagulls at the beach?

2928 **WYR** bring back acid wash jeans or bell bottoms?

2929 **WYR** dine and dash at a restaurant or shoplift a candy bar at a gas station?

2930 **WYR** get rid of snail mail or emails?

2931 **WYR** always eat in front of the TV or always eat at a dinner table?

2932 **WYR** be able to defy gravity or be immune to all viruses?

2933 **WYR** forget about all your past bad relationships or leave the memories alone?

2934 **WYR** visit Radio City Music Hall or Sydney Opera House?

2935 **WYR** swim in the ocean with box jellyfish or walk through the rainforest filled with dart frogs?

2936 **WYR** read the spoiler alerts before every movie or read the last chapter of the book before you start chapter one?

2937 **WYR** create your own greeting cards or buy them from the store?

2938 **WYR** be showered with attention and affection or expensive gifts as a sign of love?

2939 **WYR** attend a zombie walk or a pub crawl?

2940 **WYR** have the fastest motorcycle or fastest sports car?

2941 **WYR** be a ninja or a samurai?

2942 **WYR** cry too easily or get angry too easily?

2943 **WYR** be hungover in church or at work?

2944 **WYR** never use lotion or sunscreen again?

2945 **WYR** be trapped under your ex's bed or in your parents' closet?

2946 **WYR** know how to use a blow dart or slingshot?

2947 **WYR** never pay for another traffic ticket again or have free parking anywhere there's a charge?

2948 **WYR** go on a Mediterranean cruise or an African safari?

2949 **WYR** live in a cave behind a waterfall or in an underground cavern?

2950 **WYR** be superficial or superstitious?

2951 **WYR** bring back cobblestone streets or the horse and carriage as a mode of transportation?

2952 **WYR** make webs like a spider or lift 1,000 times your weight like an ant?

2953 **WYR** live without smoke detectors or fire extinguishers?

2954 **WYR** your significant other cheat with your best friend or with your twin?

2955 **WYR** eat the dangerous delicacy of pufferfish or sip absinthe?

2956 **WYR** only be allowed to use drive-throughs or only go inside (no drive-through) when you eat out?

2957 **WYR** visit a chiropractor or acupuncturist when your back hurts?

2958 **WYR** always judge others or always have others judge you?

2959 **WYR** be in allegiance with Tony Soprano or Tony Montana?

2960 **WYR** never pay another electric bill or cell phone bill again?
Electric bill

2961 **WYR** save Mufasa from *The Lion King* or Bambi's mom from dying?

2962 **WYR** have a good credit score or good reputation?

2963 **WYR** date someone successful but mean or someone unemployed but sweet?
Unemployed but Sweet

2964 **WYR** hang out with wild Miley Cyrus or the *Hanna Montana* version of Miley?
Wild Miley Cyrus

2965 **WYR** drive a Ford Mustang or Chevy Camaro?

2966 **WYR** never go inside another nightclub or never go inside another bar?
Nightclub

2967 **WYR** teach driver's ed or CPR to teenagers?

2968 **WYR** have hair down to your ankles or be totally bald?
Hair down to my ankles

2969 **WYR** give a public speech in front of people you respect or confess privately to a group of strangers?

2970 **WYR** tell your best friend in person you no longer like them or just stop talking to them?
in person

2971 **WYR** save a person's life or win the lottery?

2972 **WYR** charter a single engine plane or helicopter?

2973 **WYR** perform the ALS ice bucket or ALS pepper challenge?

ice bucket

2974 **WYR** learn more about your grandparents or your great grandparents?

Great grandparents

2975 **WYR** drink soda from a can or glass bottle?

glass bottle

2976 **WYR** name your child after a family member or someone who inspires you?

2977 **WYR** never take another selfie again or become friends again with someone who betrayed you?

2978 **WYR** play a hardcore game of kickball or volleyball?

2979 **WYR** wear a monitor that beeps when you're lying or beeps when you're attracted to someone?

2980 **WYR** teach aerobics or yoga?

2981 **WYR** learn how to carve wood or forge swords?

2982 **WYR** eat a cantaloupe or avocado skin?

2983 **WYR** spend 24 hours on the subway or public bus people watching?

2984 **WYR** run errands in public in slippers and a robe or shower cap and face mask?

2985 **WYR** take the road less travelled or follow in other's footsteps?

2986 **WYR** have chicken nuggets or chicken strips?

2987 **WYR** spend your time wisely or just live in the moment?

2988 **WYR** put your head in a lion's or crocodile's mouth?

2989 **WYR** break a bone in your foot or hand?

2990 **WYR** have a popcorn kernel stuck in your throat or a toothpick break between your teeth?

2991 **WYR** only watch Marvel movies or only watch DC Comic movies?

2992 **WYR** be able to record your thoughts or your dreams while you sleep?

2993 **WYR** find a way or make a way?

2994 **WYR** eat falafel balls or meatballs?

2995 **WYR** go to an indoor concert or outdoor concert?

2996 **WYR** have instant fame or gradual fame?

2997 **WYR** have your mouth freeze with a stupid smile or your eyes freeze crossed?

2998 **WYR** have a plant or goldfish that talks to you?

2999 **WYR** think with your right brain or left brain?

3000 **WYR** get blindsided at work or blindsided in love?

Looking for more?

Similar titles available by Piccadilly:

300 MORE Writing Prompts

500 Writing Prompts

3000 Questions About Me

Choose Your Own Journal

Complete the Story

Creative Writing

Your Father's Story

Your Mother's Story

The Story of My Life

Write the Story

500 Drawing Prompts

Calligraphy Made Easy

Comic Sketchbook

Creative Drawing

Sketching Made Easy

100 Life Challenges

Awesome Social Media Quizzes

Find the Cat

Find 2 Cats

Time Capsule Letters

WWW.PICCADILLYINC.COM